SARAH SIMON

WATERCOLOR WORKBOOK

30-Minute Beginner Botanical Projects on Premium Watercolor Paper

TO JESUS,
who is the Giver of all of these good gifts.

TO MY DAUGHTERS AND HUSBAND,
London, Savannah, and Colin: Thank you for inspiring, encouraging, and loving me.

AND TO YOU,
my creative friend who has found this book: May you grow and stretch and learn so much from these pages. This book is from my heart and hands, to yours. I am honored to be a part of your artistic journey.

Paige Tate & Co.

Copyright © 2021 Sarah Simon

Published by Paige Tate & Co.

Paige Tate & Co. is an imprint of Blue Star Press

PO Box 8835, Bend, OR 97708

contact@paigetate.com

www.paigetate.com

Designed by Megan Kesting

ISBN: 9781950968268

Printed in China

10 9 8 7 6 5

TABLE OF CONTENTS

INTRODUCTION

HELLO, FRIEND! WELCOME TO THE WORLD OF WATERCOLOR.

Perhaps you are brand new to this art and have been meaning to give it a try. Or perhaps you're returning to it after a long hiatus. Your last memory of watercolor might even be those trays of dried paint circles you used as a kid—that's totally OK. I created this workbook with all of these journeys in mind. It lays out the basics of watercolor so you can get your brush wet and begin painting today.

Each page features a botanical line drawing on high-quality watercolor paper. After gathering your materials and practicing a few essential techniques, you'll be ready to paint. The projects increase in complexity as you move along so that you build your skills and gain confidence with every page. It's normal to feel clumsy and slightly resistant to growth at first, but allow yourself the space—and grace—to push through. You are on the path to becoming an artist!

I believe in the magic of painting. When my paintbrush moves just right and creates a beautiful image on the paper, it can feel like I've grabbed hold of a dream and brought it to life. When the paint flows and my hands create things beyond what my mind can imagine, I enter a state of creative mindfulness. When I'm fully engrossed in my art, it's as if time stands still. This workbook comes from my hands and my heart, and it is my gift to you as you embark on your own painting journey. I want your experience to be equally fulfilling and encouraging. I want it to inspire you to continue with your painting practice and connect with the wider community of artists.

I cannot wait to see what you create!

Use the hashtag #watercolorworkbook if you'd like to share your paintings with me on social media!

ENJOY!

MATERIALS

all you need are some basic tools. A fancy brush? Nope, not necessary. You can do everything in this book with an inexpensive, student-grade paintbrush. Painting palette? Not necessary either! If you don't have one, use a dinner plate. I want you to enjoy the process and not fuss about the other stuff. I want you to see how much beauty you can create with minimal supplies and expense.

01. ROUND WATERCOLOR BRUSHES

The projects in this book can be completed with just two brushes: a Round 4 and a Round 1. I'll tell you which brushes you need for each project. I suggest student-grade Princeton brushes in the "Select Artiste" series.

Why a round brush? Round watercolor brushes are the most versatile. Applying light pressure engages just the point of the brush, giving you the control to make small details and delicate lines. Applying more pressure engages the full width and length of the brush, allowing for broader strokes and larger deposits of water and paint on your paper.

02. WATERPROOF INK PEN

I recommend using a pen to trace the outlines of each pattern before you start painting. Not only will this help you relax and get in the creative mindset for painting, but design-wise, incorporating ink will give your pieces a modern crispness. Ink is a great way to combine the precision and detail of drawing with the flowing freedom of watercolor paint.

I suggest Sakura Pigma Micron pens because they create a thin and consistent waterproof line that doesn't run or bleed when you paint over it. A size 01 (0.25 mm) or 02 (0.30 mm) pen works and will be the perfect size for the illustrations in this book.

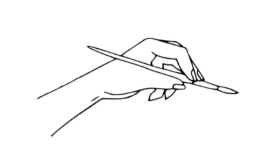

PRO TIP: How To Hold Your Brush

This is an illustration of a "classic hold" for a watercolor brush. This grip is similar to how most people hold a pen or pencil for writing. Go ahead and pick up your brush and grip the thickest part of the handle, above the ferrule (the metal piece connecting the bristles to the brush), and hold it like you are getting ready to write a letter. Think of the point of your brush like the tip of your pen! As you begin to make marks with your brush, keep in mind that you have the most control if you use your brush to pull the paint down or move it from side to side, as opposed to "pushing" the paint upward. Where you hold the brush makes a difference in the type of mark you're making. Holding the brush closer to the bristles (on the metal ferrule) gives you more control in finer strokes, like the details of a leaf. Holding it further back on the handle gives you more agility in your movement and works well for making looser strokes for a wash. The amount of pressure you use as you touch your paintbrush to paper will also affect the shape and style of the mark you create.

03. PAINT

Here are the only colors you will need to mix up all of the color recipes for this workbook. You can use dry pan watercolors to create with, however the color recipes will be easier to mix with paint from a tube. I use Winsor & Newton brand watercolor tube paints, all student-grade quality, except the Payne's Gray, which is professional.

PAINT COLORS:

Lemon Yellow

Yellow Ochre

Alizarin Crimson

Burnt Sienna

Oxide of Chromium

Cobalt Blue Hue

Payne's Gray

Ivory Black

White *(any white will do!)*

If it's in your budget to add a few more colors to your collection, I would suggest the two below. They are beautiful, and we use them throughout the book. However, if you'd rather stick with just the colors above, don't worry. I'll show you how to mix recipes that get you close to these colors, using the original paint tube colors above.

AND SOME EXTRAS:

Perylene Maroon

Perylene Violet

Throughout this book, I share the color palette I use to paint each piece and provide you with an "icon" of my painting that you can use to reference colors. If you don't want to follow my palette, or can't find the exact colors listed on the prior page, don't worry! Color is one of the most expressive tools a painter can use, and color preference is deeply personal. As you develop your skills with practice, over time you will begin to see color similarities across your palettes and painted pieces. These similarities represent your personal style and are your unique expression in the world of color. Use the colors that feel best to you.

I also want to teach you how to mix colors...and yes, I am going to give you the secret ingredients to every one of the color recipes I used for this book. Recreating my recipes is a fun and easy way to begin, but I hope you gain the confidence to start mixing your own. Remember, every color imaginable is hidden inside these primary colors. By playing around with the colors in this book, you'll learn how to make your own delicious palettes that will become an amazing form of self-expression!

PRO TIP: A Note on Gouache and White Paint

First things first, it's pronounced "guh-wash" and is a way to incorporate white into a watercolor painting. Watercolor and gouache go well together because they both can be reanimated with water. They can also be blended together to create some beautiful colors, which we will be playing with in this workbook! When you combine white pigment with watercolor paint, you're officially using gouache. Gouache paints are essentially an opaque version of watercolors. White pigment slowly lightens a watercolor pigment, fading it out by reducing its translucent quality and increasing its opacity. I like to think of gouache like I think of my coffee in the morning: a little white paint added to my watercolors is like adding cream to coffee. Your new mixture is a creamier and slightly thicker version of your watercolor. It's opaque, which means you cannot see through it as easily as the translucent watercolor, so it can be used to layer and cover any mistakes beneath. It's also a beautiful way to add highlights or create light in a dark space in your work. Most watercolor kits come with a white tube of paint, often the pigment called "Chinese White." You can mix up your own gouache by adding white pigment to your watercolor paint, and we will be doing this with many of the recipes in this book. Just like in watercolor, you don't want to layer gouache too thickly, as it may crack if it becomes too heavy. A little gouache goes a long way!

04. PAINT PALETTE

When I sit down to paint, I squeeze small dabs of my tube watercolor paint onto my palette. (I recommend using a white dinner plate!) Depending on how many colors I want to use, and how much space I have available, I like to place the dabs a few inches apart to leave some room to blend colors. I tend to place the pure pigment dabs near the outer edges of the palette and then mix the colors and water closer to the center of the palette.

05. WATERCOLOR PAPER

Good news! The project pages of this book are made out of watercolor paper—200 gsm cold press, wood-free paper, to be precise. (Pretty amazing, right?) Should you enjoy yourself in this workbook and want to continue painting after you've completed all the projects here, I suggest continuing to use a minimum of 200 gsm cold press paper. Or, if you're looking to invest a few more dollars in a paper that will really enhance the beauty of your final pieces, spring for a professional-grade watercolor paper, like the Hahnemühle brand.

06. WATER JAR

A clear container that's shorter than the length of your brushes makes it easy to rinse between paint strokes and allows you to see when your water needs changing. (I recommend a 6-ounce Mason jar.) When it comes to changing the water, some say that you want your water to remain clean enough that a goldfish could swim in it. If they were to swim in my water, I'm afraid my fishies wouldn't fare very well! I always start with clear room-temperature water, but it muddies up pretty quickly. As you begin to paint and develop your style, you can see if you don't mind a little muddiness to your wash water, or if you prefer to follow the goldfish rule and simply refill your water as you go. Either way is fine.

07. BLOTTING TOWEL

Blotting is the process of removing color pigment from a wash. You can use a paper towel or a damp or dry brush. (I'll cover this technique more in the techniques section.)

NOTE:

This book gives you the tools and basic information you need to get started with watercolor, but it is not a comprehensive guide. If you enjoy yourself and want to learn more about the intricacies of this fine art, I suggest an in-depth study of watercolor using my first book, Modern Watercolor Botanicals.

TECHNIQUES

WATERCOLOR WASH

A WASH is a transparent layer of color brushed onto your watercolor paper. Whether you're painting a small flower or an immense seascape, the wash will begin the process for almost every watercolor piece you paint.

MOVEMENT AND SHINE

Finding the right balance of water and paint is the key to creating lovely pieces, and it starts right on your palette. Before the paint even touches your paper, it needs to be mixed on your palette and have both movement and shine.

To animate your palette, or "wake up" your paints, you'll use your brush to bring water from your water jar to your palette with paints. You can take your brush back to your water as many times as you need to wake up the paint mixtures on your palette.

If you're working out of dried tube paint or cake/pan watercolors, simply bring your water right onto the dried paint and move your brush in a back-and-forth motion to engage the dry color. If you're working out of wet tube paints, treat the fresh dab of paint as a very highly saturated version of dried paint. In other words, you don't need much! Use your brush to draw a small bit of wet paint away from the freshly poured dab, then add water to that smaller area. You can see in the pictures on the next page that the paintbrush is engaged in the small puddle of blue paint water next to the highly saturated fresh dabs of paint.

To see if you've added enough water, pick up your palette and tilt it vertically, shifting it back and forth. If you see small raindrops of your paint and water mixture beginning to form, you're on the right track. You're after both movement (the small drops moving on the surface) and shine (the surface of the mixture shining and reflecting the light).

Since paint dries quickly, it works best to animate just one or a few colors at a time. You'll repeat wetting the paint on your palette again and again as you use different colors in the creation of your painting.

PAINT CONSISTENCY:

In watercolor, every time you bring paint to paper, you will be using a mixture of paint and water. For the washes in the projects in this book, the consistency of that mixture is about 80 percent water and 20 percent paint. For finer details, it will be about 50 percent water and 50 percent paint. Check out the next page for some helpful visuals of how I like to think about these consistencies.

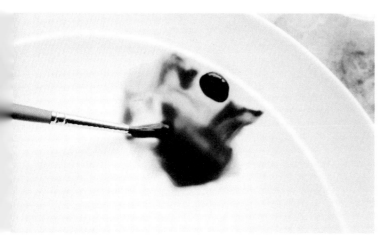
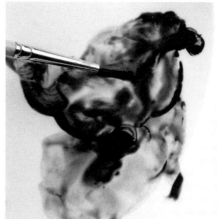

80W/20P:

80w/20p above stands for 80 percent water and 20 percent paint. Think of it like soy sauce and wasabi. If you've ever enjoyed sushi before, you know how potent wasabi can be—a little goes a long way! If you think of your water as soy sauce, and the dab of paint as wasabi, you will be well on your way to mixing a perfect paint consistency and beautifully transparent watercolor washes.

50W/50P:

50w/50p above stands for 50 percent water and 50 percent paint. With this consistency, you want more pigment in your water-to-paint ratio. This mixture is thicker and saturated with more paint; it favors the thickness of heavy cream.

COLOR SWATCHING

Creating a watercolor wash with movement and shine is your first step to begin painting. A "swatch" is just a wash of pure color. We are going to practice creating washes by making swatches of each of the colors I suggested in the Materials section.

NOW IT'S TIME TO PRACTICE…

It's time to start practicing some techniques. On the next few pages you'll find instructions to guide you along. The watercolor paper in the second-half of this book has dedicated space to practice. We had to structure the book this way to be able to provide all this information alongside premium watercolor paper. We know this requires you to flip back and forth for the first few techniques, but once you get to the projects, all of the instructions will be on the adjoining pages—no flipping required! And remember, while the paper is premium, this is a workbook, so use it as such! If your pages aren't wavy and tattered by the end, you haven't played enough with your paints!

PRO TIP: Color Matching and Swatching

If you don't have the exact paint colors listed in the materials section, swatch the colors that you can get. If these colors are new to you, I suggest swatching them on scrap paper, or in the margins of this workbook, before you put them down in your swatch chart. Once they dry and you are sure of their color, add them to your book. Keep in mind that watercolors dry 10 to 20 percent lighter than when they are wet. My swatches are dry, so they will look lighter than your wet swatches to start.

Since we are working on white paper, we'll skip creating a color swatch of the white paint. Whites are wonderful to experiment with when you are playing with gouache, as you will explore more as we create color recipes on page 33. Different brands and grades of white pigment have different consistencies, staying power, and opacities, so I suggest playing around with white paints on your own and discovering what you enjoy using in combination with your favorite colors.

WASH

To practice, please flip to page 30 of your watercolor paper. Above each practice row, you will see a row of my washes, labeled by color. On the bottom, you'll see a row of empty boxes, ready and waiting for your swatch! Follow the instructions below to practice.

STEP-BY-STEP

01. Select the first color you'd like to swatch. You'll be using your Round 1 brush for this exercise. Add water to animate the paint on your palette, creating that 80w/20p consistency. Remember, you want movement and shine!

02. Fill your watercolor brush by brushing your paint bristles back and forth in the water-and-paint mixture on your palette.

03. Take your filled brush to your watercolor paper and stroke your brush from left to right and right to left. Work to fill in the square with this filled brush until you notice the texture of the paper beginning to show through your strokes. That's your cue to refill your brush.

04. To complete your WASH, dip your paintbrush into your water jar and return to your paper, using the water in your paintbrush to smooth out hard lines and invite the pigment into the whole square. Watercolor paint moves to where the paper is wet— so by wetting a nice smooth square, you are telling your paint that this is where you'd like it to hang out and dry.

05. Label your square with your paint color and continue creating color swatches for all of your paint tubes.

INK

The lines for every project in this book are printed for you and will not dissolve when you add watercolor. That said, I designed these projects to first be outlined with a water-proof pen (see Materials on page 3) and then painted. Getting in the habit of outlining your designs is great practice for when you start drawing your own designs. Plus, tracing is incredibly calming and relaxing!

PRO TIP: Ink

Test your pen tips on the bottom of this page to see what types of marks you can make with your pens.

You will have the most control over your lines when you pull your pen down toward you. Move your paper as you work so you can continue to pull lines, marks, and strokes toward you.

If you have different sized pens, you can add visual interest by alternating the thicknesses of your lines. Try a few lines in a very small pen tip size, and then make a bold line with a larger pen tip size. Play around!

TEST YOUR PENS HERE:

WET-IN-WET

Next, we are going to learn the WET-IN-WET technique, which is the process of adding wet paint into wet paint. You can use this technique to create shadows, high-to-low contrast, and interesting movement in your watercolor paintings. The goal is to introduce a more saturated, brighter splash of color into the lighter wet wash you've already laid down. A 50w/50p consistency for the paint you're dropping in will be perfect for a wet-in-wet. When you introduce, or "drop in," a saturated wet color into the lighter wet base wash, the newly introduced paint will bloom from your brush, moving in interesting ways into the wet wash boundary. (This is commonly referred to as a "watercolor bleed" or "veining," but I like to think of it as "watercolor fireworks"!)

Be prepared: once you drop the color into the wet boundary, the way the paint moves will be unpredictable and mostly out of your control. Don't worry, this is a good thing! With wet-in-wet, your paint makes beautiful effects that you could not achieve with a brush. In many ways, you are not really "painting" in wet-in-wet; you are merely releasing the paint from your brush and letting it do its thing. It's a beautiful way to create clouds, oceans, flower petals, and more.

Be mindful that this technique relies on a bit of speed. You will add your wet-in-wet application soon after painting your wash, so you want to have all of your paint mixtures ready to go.

WET-IN-WET

Select a light color and a dark color. I'm using Yellow Ochre as my light color, and Alizarin Crimson as my dark color. Before you start, double-check your palette. Are your chosen colors animated? Can you see movement and shine? If so, you're ready to begin!

STEP-BY-STEP

01. Next to my example on page 31, find the empty box in the top left side of your page. WASH the box with your light color using your Round 1 brush.

02. Before your light wash begins to dry, use your paintbrush to bring some of your darker color in, using 50w/50p for the paint consistency you're dropping in. Fill your bristles with the darker color from the palette, then lightly touch your paint-saturated bristles to the wet wash on your paper and lift your brush. Voila! This is how we smoothly build transparent color without hard lines.

03. Notice that wherever you place and lift your paintbrush, you leave the highest saturation of color. This is a great tip to keep in mind as you paint because this is how you build color in your art. Whichever section of your piece you would like the darkest, drop in color and lift your paintbrush there. You can repeat this dropping in of color as many times as you wish, and this will build the saturation in the spot you lift your brush. Timing comes into play here as well! Remember, you can make changes to your wet-flowing wash, as long as it is wet. Dropping in saturated 50w/50p color with the WET-IN-WET technique as it begins to dry will give you an even more saturated color in that area.

04. Once you have completed WET-IN-WET in the practice box, it is time to practice this technique using the flower on the same page. First, INK the flower with your pen using the tips you learned about inking on the previous page. Then, using your Round 4 brush, follow these WET-IN-WET steps to paint your own flower below mine!

NOTE:

If your attempt at adding color isn't flowing into "exciting fireworks," it's most likely because your light wash boundary has already begun to dry. Don't worry. Just WASH your entire square again, rewetting the boundary with the water from your jar and adding the base wash color you were using. Once you've wetted your square (ensuring movement and shine!), dab the more saturated paint into the light wash and celebrate your fireworks!

For very light flowers, I will often wash the entire flower in my clear water, creating movement and shine with JUST water. A very light-colored watercolor flower actually begins with a water wash that starts clear, or almost clear, and then you use the wet-in-wet technique to introduce the lightest of colors. By slowly building saturation with this technique, you'll get whimsical botanical wonders that dry airy and light.

The most natural way to add wet-in-wet for botanicals is to locate the base of the petal or leaf, or find where it attaches to the rest of the plant. Slowly build color there, leaving the ends of the petal or leaf the lightest in color.

How can you tell if your paint is dry? Make a flat palm and hover your hand a quarter-inch above the boundary. If you feel any coolness coming up from the paper, your paint is still wet!

WET-ON-DRY

Most people think of watercolor as a transparent, dewy medium with a smooth and fast-drying application. While this is true most of the time, you can also achieve bolder effects with your watercolor paints.

One way to do this is with the WET-ON-DRY technique, which involves waiting for the first layer of your wash to completely dry and then applying new paint to the dry surface. This method works great for layering color, adding fine lines and details, and adding definition to your pieces.

For small areas of higher saturation (for example, flower centers that you would like to be more detailed and concentrated in color), it's best to use a smaller brush (such as your Round 1) to apply new wet paint to dry paint on your piece. For finer details, aim for a 50w/50p paint consistency.

For larger areas, like a petal, you can use a larger brush (like your Round 4) and simply layer a new wet wash on your existing dry base wash. Because watercolor is known for its transparency, you can create depth in your pieces by overlaying your washes and building the color saturation slowly. The wet-on-dry technique is also called "glazing," which is just the fancy term for laying a wet layer of watercolor to "glaze" over a dry layer.

WET-ON-DRY

Select a light color and a dark color. In my flower example, I'm again using Yellow Ochre as my light color, and Alizarin Crimson as my dark color. Before you start, double-check your palette. Are your chosen colors animated? Can you see movement and shine? If so, you're ready to begin!

STEP-BY-STEP

01. Next to my example on page 31, find the empty box in the top right side of your page. WASH the box with your light color using your Round 1 brush.

02. Now, wait for your light wash to dry! This would be a great time to INK the flower below the box you just painted that we are going to practice painting next.

 Once your WASH is dry, we can practice adding a WET-ON-DRY wash on top. As you can see in my example on page 31, there are a few ways to use this technique.

 You can GLAZE, which is what I did in my example and is exactly what it looks like: adding a new layer of a wash on top of your dry wash. In watercolor, glazing is just another word for layering. Each wash you layer on top of one another is visible underneath because watercolors are transparent. Flowers become more dynamic when you add a WET-ON-DRY layer. You can use this technique to paint a shadow, build color saturation, or differentiate one petal from another.

03. Let's practice a WET-ON-DRY layer of the darker color on top of the lighter. Use your paintbrush to bring some of your darker color in, using 80w/20p for the paint consistency you're using. Fill your bristles with the darker color from the palette, then wash a square shape on top of your dry light wash.

04. Another way you can use the WET-ON-DRY technique is by making small concentrated marks. This is a fantastic technique to use when you would like to produce crisp, sharp edges—think how lovely this will be to paint in flower details!

 Let's practice this WET-ON-DRY technique, also on top of our light dry wash. Use your paintbrush to bring some of your darker color in, using 50w/50p for the paint consistency you're using. You're making small marks, so you don't need your paint to move and shine—in fact, you want it to stay put! For more controlled, detail work, you can use the 50w/50p paint consistency, (or even 20 percent water and 80 percent paint to get a really saturated mark that will stay where you would like it). Fill your bristles with the darker color from the palette, then using light pressure, make a few marks on top of your dry light wash.

05. Once you have completed your WET-ON-DRY practice box, it is time to practice this technique using the flower on the same page. First, INK the flower with your pen using the tips you learned about inking above. Then, follow these WET-ON-DRY steps to paint your own flower next to mine, adding both of your new WET-ON-DRY techniques to your flower, using your Round 4 brush for the WASH and your Round 1 for the detailed WET-ON-DRY marks.

BLOTTING

Now that we have practiced how to add color to our art with the wash, wet-in-wet, and wet-on-dry techniques, we are going to learn how to take color away from our pieces.

Blotting is the process of removing pigment from a wash, which allows you to create points of highlight within a wet boundary.

THERE ARE THREE DIFFERENT WAYS YOU CAN CREATE HIGHLIGHTS WITHIN YOUR WATERCOLOR ART:

01. RESERVE

Don't wet the area, and it will stay the white of your paper! After all, paint cannot move into an area that isn't wet. This is the traditional way to create highlights or bright white shapes in watercolor. To RESERVE is simply to not paint the area of your art where you would like the white of the paper to shine through. By leaving the white of the paper free of paint, the paper generates the light tones in a painting. So, if you know that you'd like a part of your piece to sparkle or be the brightest white, reserve those areas by painting around them. See the painted flower example on page 32 to check out examples of reserving on a petal.

02. BLOT

Once you've washed a section of your piece, and it's wet, you can BLOT the area with your paper towel. (Heavy pressure picks up more paint; lighter pressure picks up less.) Press the paper towel into your wet paint boundary to soak up paint splatters and areas with too much water or too much paint. Using heavy pressure will remove all of the pigment and water out of the area. It acts as a "watercolor eraser" of sorts. I'm using this technique in Picture A to the right. Using light pressure pulls out paint, but not all of the water, allowing movement to continue within the area. This technique has more of a dabbing effect, or what I like to think of as a "watercolor vacuum." See Picture B for this technique. I've painted a flower example on page 32 to show you the effects of the different blotting methods as well.

03.　DRY BRUSH

OR The Sweep, The Damp Brush, or The Thirsty Brush Method

As you can see, the DRY BRUSH method (in picture C) has a few names, but they are all doing the same thing: sweeping color from one area of your wet boundary to another. You can use an actual dry brush (one you haven't been painting with at all), or you can dry the bristles of your current brush with a paper towel and use that. This technique is the subtlest way to remove color since blotting with a paper towel has a more dramatic effect. I like to use the brush I have in my hand, and use a paper towel to squeeze the water from its bristles. You're essentially creating a "thirsty brush" (hence the nickname mentioned above), and when you "sweep" these "damp brush bristles" through one area of your wet boundary to another, you are pushing the color along. This leaves a highlighted area you've just created by sweeping the color away to another space of your wet boundary! Again, this is subtle, but the most lovely way to create a highlight in your wet boundaries. See the painted flower example on page 32 to check out examples of the dry brushing effect on a petal.

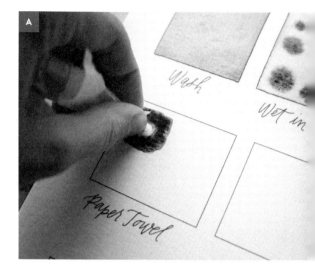

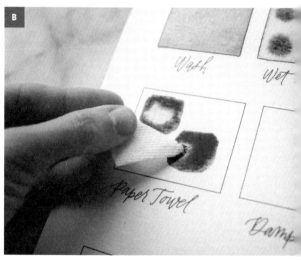

PRO TIP: Paper Towels

Keep paper towels on hand at all times while you're painting. In addition to creating wonderful contrasting light spots within your wet boundaries, they're handy for absorbing unwanted puddles of water or cleaning up accidental paint splashes.

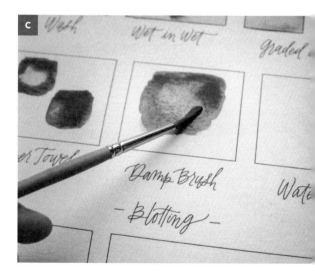

BLOTTING TECHNIQUES

It is time to practice these blotting techniques. First, INK the flower on page 32 with your pen using the tips you learned about inking on page 11. Then, follow these blotting steps to paint your own flower next to mine.

STEP-BY-STEP

01. WASH your flower in Yellow Ochre, using your Round 4 brush for this exercise. (Remember, look for that movement and shine!)

02. To practice RESERVING areas of your flower, simply do not paint to the edges of the petals and leave the center of your flower white as well. As you can see from my example on page 32, I've reserved the area in example 4.

03. Add WET-IN-WET color pops of Alizarin Crimson, dabbing your color in near the center of your flower.

04. Practice with your paper towel by dabbing lightly in some areas of your wet petals, and pressing more firmly in others. You can start to see the difference of pressure on your wet flower petals—where a paper towel will remove color completely, and where it can be used to pick up excess water or just dab out a bit of color.

05. Rinse any excess paint from your brush by rinsing it in your wash water jar. Now, wring your brush's extra water drops out by running the bristles along the edges of your water jar. And now, for good measure, to make sure you've gotten most of the water out, you can use a paper towel to dab your bristles as well. You've essentially made your brush "thirsty!" Now, use this thirsty DRY BRUSH in a sweeping motion, moving pigment from one area of the wet boundary of your flower to another. Because the bristles are thirsty, they will absorb pigment, so if you go back for another sweep, make sure you use a paper towel to remove any water and pigment you may have picked up from your first sweep. This technique can be repeated as much as you'd like while your wash is wet to create a nice highlight to your flower petal.

BOUNDARIES

An amazing thing about watercolor is its ability to form a crisp, clean edge where the water meets the paper. Where the water stops, the paint will stop. Paint will move within the watercolor boundary as long as the area remains wet.

You can direct where you would like the paint to go with your brush by creating a wet boundary. Every time you bring your filled paintbrush to your watercolor paper to make a wash, you create a wet boundary. By creating movement and shine with your paint consistency within that boundary, you give yourself time to add more color to your wash using the wet-in-wet technique or to remove color from your wash by blotting.

You can also blend boundaries as long as both boundaries are still wet. When the boundary of one wet wash touches the boundaries of other wet washes, the colors begin to move and blend into one another—because paint moves where there is water. This is one of the unexpected beauties of watercolor. By guiding your paint washes to overlap their wet boundaries, lovely blending can happen. Boundaries are also a great thing to be aware of when you do NOT want two areas to blend. If you want defined, separate boundaries, make sure your wet boundaries don't touch!

As a boundary begins to dry, your ability to change the coloring within that wet boundary lessens. Once the boundary is dry, the paint is set and formed. Adding water or another layer of watercolor to a dry boundary can leave you with new lines, jagged edges, or unexpected effects. If you aren't looking for these types of effects, avoid disturbing a boundary that is already drying. Learn to walk away and let the paint do its thing. And come back later to add some wet-on-dry techniques if you think it needs an extra touch of pizzazz!

THREE TYPES OF BOUNDARIES

These flowers show the effects of three different types of boundaries. Each style has its own charm and appeals to different artists.

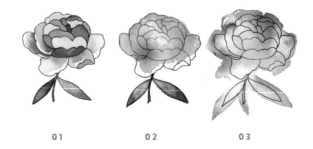

01 02 03

01. DEFINED BOUNDARY

Notice how each petal is its own boundary. You achieve this by NOT allowing the boundaries to bleed together. This means playing a bit of hopscotch while you paint, only painting petals that have dry neighbors. Think of this like a stained glass window, where each line separating each petal is like a pane separating each different panel of colored glass. The best way to do this is to complete the wash (and wet-in-wet, or whatever technique you'd like to use while your boundary is wet) on one petal and allow it to dry before moving to another. In this example, I used a wash on some petals, and on others, I reserved white space while using a wash and wet-in-wet. With this technique, each petal has its own well-defined boundary and beautiful mix of high-to-low paint concentration within that boundary. This style gives you a sharp and crisp look.

02. LOOSE BOUNDARY

For this style of boundary, the entire flower is wetted down at the same time, allowing each petal to blend with its neighbors. You stay within the defined outer edges of the flower, but paint your flower all at once using all of your techniques (here I used a wash, wet-in-wet, blotting, and reserving the edges of the petals). This approach achieves more of a loose watercolor look with concentrations of saturated color in some parts of the flower, and highlights shining through where you have blotted or left areas of your flower without a wash. It's also faster!

03. UNDEFINED BOUNDARY

Since your inked lines already define the flower's form, you don't have to paint in the lines to have a beautiful botanical. With this technique, you water down the paper freely with a wash and use the wet-in-wet method to drop in colors, not worrying if they bleed beyond the inked flower outline. This technique gives you a very free-flowing look that is loose and a bit wilder than the other two styles of boundaries.

Keep in mind that you can combine all three of these different types of boundary styles in one piece. Or, if you find you prefer one in particular, you can stick with that style and use it throughout the book. There is no "right way" to approach your projects, so feel free to play and experiment as you go!

PAINTING BOUNDARIES

Let's practice a few recipes while we play with our new boundaries on page 32. Keep your Round 4 and Round 1 brush handy for this practice—we will use them both. Use the Round 4 for the larger boundaries, and the Round 1 for the smaller boundaries.

BELOW ARE THE COLORS YOU WILL NEED TO PREPARE YOUR PALETTE:

FOR YOUR FLORALS:

White

Yellow Ochre

Alizarin Crimson

AND the recipe combination of these three colors, which is

Sunrise: 10% White + 80% Yellow Ochre + 10% Alizarin Crimson

FOR YOUR FOLIAGE:

Oxide of Chromium

Payne's Gray

AND the recipe combination of these two colors, which is

Monstera: 60% Oxide of Chromium + 40% Payne's Grey

STEP-BY-STEP

01. Flip to page 32. First, INK the flowers with your pen using the tips you learned about inking on page 11. Then, follow the steps on the next pages to explore what a difference painting with varied boundary techniques can be.

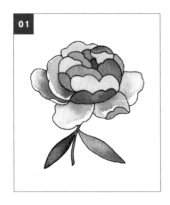

THE DEFINED FLORAL

For this floral, I suggest using your Round 1 Brush.

01. EACH petal is its own wash. Hopscotch around your piece as you add a slightly different-colored WASH to each petal. Some petals are a Yellow Ochre wash with a reserved edge in white, with Alizarin Crimson dropped in using the WET-IN-WET method. Some petals are a wash of Sunrise. Because each boundary is so small, my paint consistency on my palette is about 50w/50p. We do not need a lot of movement and shine with this method.

02. Paint as many petals as you can without one overlapping the other, and while those dry, move onto the loose floral practice.

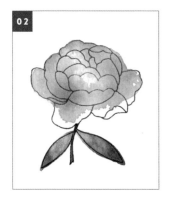

THE LOOSE FLORAL

For this floral, I suggest using your Round 1 Brush for your leaves and your Round 4 for the flower.

01. The ENTIRE Flower is its own wash. And here, because we want time to make changes, we want to ensure we have movement and shine in our entire flower at the same time—all petals wet at the same time! WASH your entire flower in Yellow Ochre, RESERVING some edges of the outer petals in the white of the paper.

02. Use the WET-IN-WET technique to add Sunrise and Alizarin Crimson.

03. Use the BLOTTING technique to create points of light. I did a little bit in the center.

04. WASH your leaves and stem in Oxide of Chromium.

05. Use the WET-IN-WET technique to add Payne's Gray and Monstera.

06. This floral is done! Check on the Defined Boundary floral and see if you can add a few more petals or leaves at this point.

THE UNDEFINED FLORAL

For this floral, I suggest using your Round 4 brush.

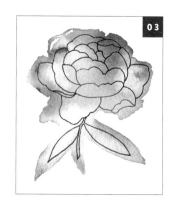

01. The entire flower (petals, stem, and leaves) is its own wash. And here, because we want time to make changes, we want to ensure we have movement and shine in our entire piece at the same time—all petals, leaves, and stem wet at the same time!

02. Check your wash water jar—is it clear? If not, refresh your water for this next step.

03. WASH your entire flower in clear water. Go ahead, go outside the lines. Yes, you can! It will be OK. WASH all of your petals, stem, and leaves, moving outside of the lines.

04. Use the WET-IN-WET technique to add Yellow Ochre on the left of the clear wet boundary, Alizarin Crimson on the right, and Sunrise in the center. Again, continuing to use the WET-IN-WET technique, add Oxide of Chromium to the area near your leaves and stem.

05. DRY BRUSH and BLOT out areas with your paper towel to create highlights within this free-flowing wet boundary.

06. Now sit back and let it dry and do its watercolor thing. (Feel free to check on the Defined Boundary floral and patiently finish any unpainted petals or leaves at this point!)

Each piece you work on in this *Watercolor Workbook* can be done in any of the styles we have just practiced: Defined, Loose, and Undefined. And feel free to mix and match! When you look at the watercolor projects ahead of you, I want you to feel the freedom to move in your own creative expression. Now that you have the tools to create the techniques, and the ability to identify watercolor boundaries—and how you can control them as an artist—you have the skills you need to begin!

Paint inside of the lines and follow my color recipes, or go wild and don't worry about the lines or mixing up the exact colors. This is YOUR artistic journey. I invite you to explore whatever feels most freeing and exciting for YOU. I simply cannot wait to see what you create.

You know the steps...now it's time to dance with your brush and mix up some beautiful paint colors!

COLOR RECIPES

We will begin most projects in our lightest toned colors of the palette and then move to the darker ones at the end. This will help you save a few trips to the sink to refresh your wash water as well.

Mixing color recipes begins on your palette. Be sure you have room to mix and blend your colors, so you can watch them move and swirl. Use more than one paint palette or dinner plate if needed—I personally have a large stack of palettes I keep on hand with my dried recipes that I reanimate regularly. You start by animating each color with water, then blending. Mixing the recipes from freshly poured tube paint is the easiest, but you can also mix recipes from dried pan or previously dried dabs of paint.

The black arrow represents the motion of my paintbrush as I mix these two colors. In picture A, you can see I've added water to the paint on the palette, creating movement and shine. The consistency of both the Yellow Ochre paint puddle on the right and the Alizarin Crimson paint puddle on the left are 80w/20p. Remember, as we begin to mix

color recipes, we are mixing the puddles together—not the concentrated pigment dabs. Of course, if you'd like a more saturated color, you can use your brush to add a bit of more concentrated pigment into your new recipe, but remember: a little paint goes a long way.

When you're mixing your recipes, start by mixing the lightest pigments first, and slowly adding in the darkest. For example, when mixing the recipe for Blush (see picture B), begin by mixing White + Yellow Ochre first, then add in a bit of Alizarin Crimson. Use darker pigments sparingly. Think of them as the salt of the food world—too much can overpower the entire mix.

As you create your recipes, feel free to use the section on page 33 to test your mixes in the margins of your workbook to see if you are headed in the right direction. Make small test brush strokes before you fill in your final recipe square. And, as you begin to work through your projects, feel free to use the margins next to the instructions to test your recipe colors before using them on your final piece.

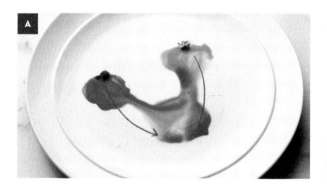

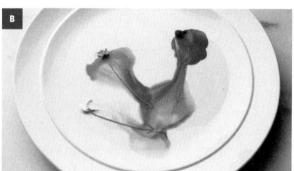

Colors and pigments within each tube of paint can vary, for a myriad of reasons. Colors appear differently across brands and grades. For example, a Winsor & Newton brand professional-grade Payne's Gray is very different from a Winsor & Newton brand student-grade Payne's Gray. (I use professional-grade Payne's Gray to mix the recipes in this book.) So even within brands, a grade can affect the pigments that have been used to create the color. And then there is the color Yellow Ochre, which seems to be the same no matter what brand or grade you purchase. This is to all to say: color is an invitation to play! Don't be discouraged by this! See this as an adventure in color and learning. This is how you discover new colors. Learn the basic mixing skills here that you need to create some beautiful colors, and then explore and create a color palette that feels like a fabulous way to express yourself. And be sure to make a note of the colors you used to mix them up, so you can recreate them again later.

NOW, LET'S MIX UP SOME BEAUTY!

BOLD BOTANICALS COLOR RECIPES

COLOR:	RECIPE:
BUFF:	90% White + 10% Yellow Ochre
YELLOW ROSE:	10% White + 80% Lemon Yellow + 10% Alizarin Crimson
BLUSH:	50% White + 30% Yellow Ochre + 20% Alizarin Crimson
SEASHELL:	70% White + 20% Yellow Ochre + 10% Alizarin Crimson
SUNRISE:	10% White + 80% Yellow Ochre + 10% Alizarin Crimson
ROSE:	10% White + 40% Yellow Ochre + 50% Alizarin Crimson
TAUPE:	10% White + 20% Yellow Ochre + 20% Alizarin Crimson + 50% Burnt Sienna
DAHLIA PINK:	10% White + 19% Yellow Ochre + 30% Alizarin Crimson + 40% Burnt Sienna + 1% Ivory Black
BURNT ROSE:	35% Burnt Sienna + 60% Alizarin Crimson + 5% Ivory Black
DUSKY PINK:	44% White + 1% Payne's Gray + 55% Alizarin Crimson
LAVENDER:	10% White + 5% Yellow Ochre + 45% Payne's Gray + 40% Alizarin Crimson
FRUIT PUNCH:	60% Perylene Violet + 40% Alizarin Crimson
WINEBERRY:	80% Perylene Violet + 20% Payne's Gray
PEA GREEN:	70% Yellow Ochre + 30% Oxide of Chromium
OLIVE GREEN:	40% Oxide of Chromium + 60% Burnt Sienna
SAGE:	50% White + 20% Yellow Ochre + 30% Oxide of Chromium
EUCALYPTUS GREEN:	50% White + 10% Yellow Ochre + 20% Oxide of Chromium + 20% Cobalt Blue Hue
LEAF GREEN:	20% Oxide of Chromium + 50% Burnt Sienna + 30% Payne's Gray
MONSTERA:	60% Oxide of Chromium + 40% Payne's Gray
SMOG:	40% White + 30% Yellow Ochre + 20% Alizarin Crimson + 10% Payne's Gray
HYDRANGEA BLUE:	50% White + 10% Lemon Yellow + 40% Cobalt Blue Hue
SLATE:	30% White + 30% Oxide of Chromium + 40% Payne's Gray
MOODY BLUE:	50% Cobalt Blue Hue + 40% Payne's Gray + 10% Alizarin Crimson
STONE:	20% White + 10% Oxide of Chromium + 20% Burnt Sienna + 30% Payne's Gray + 20% Ivory Black
SOIL:	25% Burnt Sienna + 25% Payne's Gray + 50% Ivory Black
BRANCH:	40% Yellow Ochre + 50% Burnt Sienna + 10% Ivory Black

If you didn't pick up the optional colors, Perylene Maroon and Perylene Violet, below are recipes made from your basic colors that can get you close to these pigments. Also, below are the color recipes Fruit Punch and Wineberry reimagined, using the original nine colors in the materials section. You can substitute these out when needed:

COLOR:	RECIPE:
PERYLENE MAROON SUBSTITUTE:	39% Burnt Sienna + 60% Alizarin Crimson + 1% Ivory Black
PERYLENE VIOLET SUBSTITUTE:	60% Alizarin Crimson + 40% Payne's Gray
FRUIT PUNCH SUBSTITUTE:	15% Burnt Sienna + 5% Payne's Gray + 80% Alizarin Crimson
WINEBERRY SUBSTITUTE:	50% Payne's Gray + 50% Alizarin Crimson

SKIN COLORS

There are several floral ladies for you to paint in the projects of this book. I've provided the color recipes below so you can paint them any shade you'd like.

COLOR:	RECIPE:
LIGHT:	80% White + 20% Burnt Sienna
LIGHT MEDIUM:	80% White + 15% Yellow Ochre + 5% Lemon Yellow
LIGHT MEDIUM TAN:	70% White + 30% Burnt Sienna (yes! This is the same as Light, just with MORE Burnt Sienna)
MEDIUM:	60% White + 10% Yellow Ochre + 5% Lemon Yellow + 25% Burnt Sienna
MEDIUM TAN:	30% White + 15% Yellow Ochre + 5% Lemon Yellow + 40% Burnt Sienna + 10% Ivory Black
TAN DEEP:	20% White + 10% Yellow Ochre + 5% Lemon Yellow + 45% Burnt Sienna + 15% Ivory Black + 5% Alizarin Crimson
DEEP:	15% White + 10% Yellow Ochre + 5% Lemon Yellow + 45% Burnt Sienna + 20% Ivory Black + 5% Alizarin Crimson

Since we mix up so many recipes for this workbook, you may want to use a few plate palettes to create them all. Mixing from freshly-poured tube paint is the easiest, and once the recipe dries, it helps to make notes about which recipe mixture is which on your palette (sticky notes help me keep mine straight).

MIXING COLORS

We are going to begin with the lightest recipes and work to the darkest (hello, beautiful rainbow of colors!). Remember, if you don't have these exact paint colors, don't fret! Mix up a recipe using your own similar colors, then make a note under the swatch to remember how you made your recipe.

STEP-BY-STEP

01. Let's start with Buff, a subdued creamy mixture of White + Yellow Ochre.

02. Flip to practice page 33. Beginning on your palette, bring water to your paints to create movement and shine in both of these colors, separately. Use your Round 1 brush for this exercise.

03. Now, use your wet paintbrush to blend these two wet paint puddles (see pictures on page 24).

04. Swirl the colors together with your paintbrush and add in more pigment of either color until you've mixed up a nice Buff.

05. Test the recipe with a few light brush strokes in the margins of your workbook and adjust the color as needed.

06. Once you're happy with your color, create a nice light WASH in the first box, below the rectangle with the Buff color swatch.

07. Before this light base wash begins to dry, use your paintbrush to use the WET-IN-WET technique to saturate the wet wash. Fill your bristles with the color recipe from the palette, then simply touch your paint-saturated bristles to the light wet wash and quickly lift your brush. Voila! This is how we smoothly build transparent color without hard lines. This is how you can use the same color to increase the intensity of saturation, creating a subtle blend of light to dark within a wet boundary. It will give your chart a wonderful and saturated dose of your new recipe colors.

08. Complete this color-mixing process following steps 1 through 7 for all the color recipes listed on pages 26 and 27. Get ready to fill these pages with some amazing colors! Note: If you don't have time to practice all your recipes now, you can also use the practice page to swatch recipes as you are creating them for each project. Just refer to the colors needed for the project and then test your recipes on the practice page before you get started!

Now that you've had a chance to mix colors, you can see that small tweaks to the amount of colors within your mixture you're creating can really change up the outcome of your overall recipes. You've also learned that just a handful of primary colors as your recipe ingredients can really mix up a myriad of beauty on your palette!

BOTANICAL PROJECTS

Hooray! You've made it to the projects. Now that you have had a chance to practice some fantastic watercolor techniques, it's time to bring your knowledge to paper. Enjoy this beautiful high-end watercolor paper, filled to the edges with my pre-drawn designs that I've created with you in mind. Alongside each project, you will find my suggested color palette and an icon I've already painted for you to reference, if you'd like. You can choose to follow my color suggestions, or creatively alter the piece as you see fit.

See this as a workbook as you continue to learn techniques and explore color, an artistic adventure that is inviting you into each page. Outline the art with your waterproof pen to warm up your hand, and feel the delicious calm that tracing brings as you turn on your creative brain. Then take a deep breath, and make that paint and water swirl on your palette as you begin your watercolor journey with the *Watercolor Workbook*, painting mindfulness with each brushstroke.

BEFORE YOU BEGIN PAINTING EACH PROJECT, KEEP THESE FIRST STEPS IN MIND:

01. Read the instructions all the way through, before you ever wet your paint or paintbrush.

02. Prepare your palette using the colors and color recipes listed.

03. Check your palette for movement and shine as you animate your colors.

04. Decide how you'd like to approach your piece: are you after a more defined or free-flowing approach? This will inform how you work with your boundaries.

05. Now, let's begin...

WASH

INSTRUCTIONS: Follow the steps on page 10 and make a wash of each paint color, using your Round 1 brush.

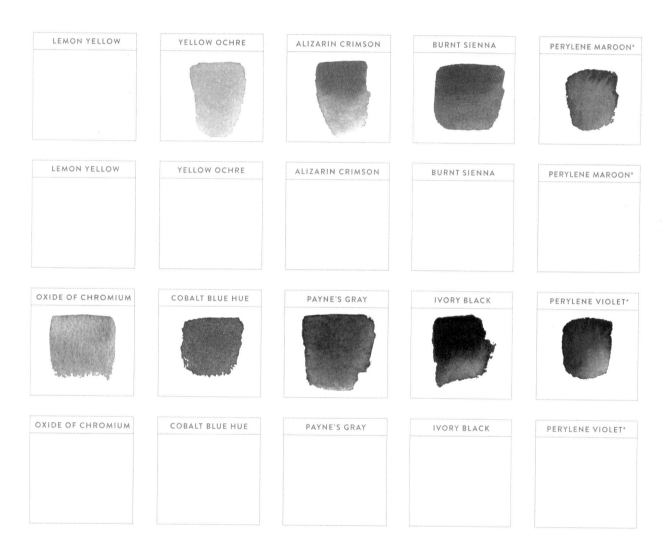

| LEMON YELLOW | YELLOW OCHRE | ALIZARIN CRIMSON | BURNT SIENNA | PERYLENE MAROON* |

| LEMON YELLOW | YELLOW OCHRE | ALIZARIN CRIMSON | BURNT SIENNA | PERYLENE MAROON* |

| OXIDE OF CHROMIUM | COBALT BLUE HUE | PAYNE'S GRAY | IVORY BLACK | PERYLENE VIOLET* |

| OXIDE OF CHROMIUM | COBALT BLUE HUE | PAYNE'S GRAY | IVORY BLACK | PERYLENE VIOLET* |

*PERYLENE MAROON SUBSTITUTE: 39% Burnt Sienna + 1% Ivory Black + 60% Alizarin Crimson
*PERYLENE VIOLET SUBSTITUTE: 40% Payne's Gray + 60% Alizarin Crimson

WET-IN-WET & WET-ON-DRY

INSTRUCTIONS: Follow the steps on pages 12 and 14. Use your Round 1 brush for the washes. Use your Round 4 brush for the flowers, and your Round 1 brush for the Wet-on-Dry flower details.

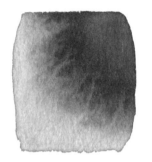

TRY IT YOURSELF

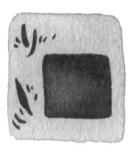

TRY IT YOURSELF

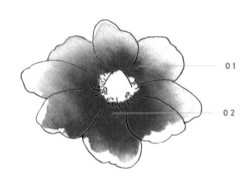

01

02

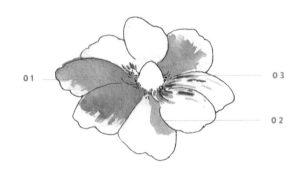

01

03

02

EXAMPLES:

01. Only 1-2 wet-in-wet drop-ins of Alizarin Crimson

02. Deeper red saturation with 3-4 wet-in-wet drop-ins of Alizarin Crimson

EXAMPLES:

01. Glazing with translucent layers

02. Create shadows with a wet-on-dry glaze

03. Flower details with concentrated wet-on-dry marks

INSTRUCTIONS: Follow the steps on pages 17 and 20. Use your Round 4 brush for blotting. Use your Round 4 and 1 brush for boundaries.

DEFINED BOUNDARY:

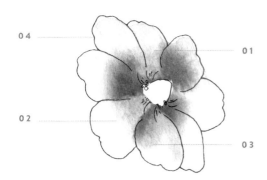

04
01
02
03

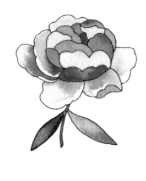

LOOSE BOUNDARY:

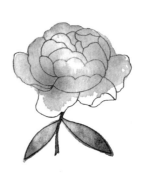
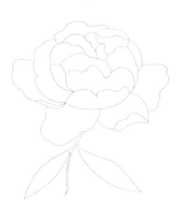

UNDEFINED BOUNDARY:

EXAMPLES:

01. Light paper towel dabbing blotting techniques

02. Heavy paper towel dabbing blotting techniques

03. Dry brush technique, sweeping color in

04. Reserved edges of the white paper

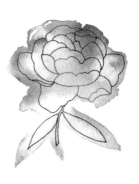

COLOR RECIPES

INSTRUCTIONS: Follow the steps on page 28. Use your Round 1 brush for this exercise.

BUFF	YELLOW ROSE	BLUSH	SEASHELL	SUNRISE
90% White + 10% Yellow Ochre	10% White + 80% Lemon Yellow + 10% Alizarin Crimson	50% White + 30% Yellow Ochre + 20% Alizarin Crimson	70% White + 20% Yellow Ochre + 10% Alizarin Crimson	10% White + 80% Yellow Ochre + 10% Alizarin Crimson

BUFF	YELLOW ROSE	BLUSH	SEASHELL	SUNRISE

ROSE	TAUPE	DAHLIA PINK	BURNT ROSE	DUSKY PINK
10% White + 40% Yellow Ochre + 50% Alizarin Crimson	10% White + 20% Yellow Ochre + 20% Alizarin Crimson + 50% Burnt Sienna	10% White + 19% Yellow Ochre + 30% Alizarin Crimson + 40% Burnt Sienna + 1% Ivory Black	35% Burnt Sienna + 60% Alizarin Crimson + 5% Ivory Black	44% White + 1% Payne's Gray + 55% Alizarin Crimson

ROSE	TAUPE	DAHLIA PINK	BURNT ROSE	DUSKY PINK

LAVENDER	FRUIT PUNCH	WINEBERRY	PEA GREEN	OLIVE GREEN
10% White + 5% Yellow Ochre + 45% Payne's Gray + 40% Alizarin Crimson	60% Perylene Violet + 40% Alizarin Crimson	80% Perylene Violet + 20% Payne's Gray	70% Yellow Ochre + 30% Oxide of Chromium	40% Oxide of Chromium + 60% Burnt Sienna

LAVENDER	FRUIT PUNCH	WINEBERRY	PEA GREEN	OLIVE GREEN

COLOR RECIPES: Use this space to check your recipes as you mix them, and before you paint them in your swatch chart.

INSTRUCTIONS: Follow the steps on page 28. Use your Round 1 brush for this exercise.

SAGE	EUCALYPTUS GREEN	LEAF GREEN	MONSTERA	SMOG	HYDRANGEA BLUE
50% White + 20% Yellow Ochre + 30% Oxide of Chromium	50% White + 10% Yellow Ochre + 20% Oxide of Chromium + 20% Cobalt Blue Hue	20% Oxide of Chromium + 50% Burnt Sienna + 30% Payne's Gray	60% Oxide of Chromium + 40% Payne's Gray	40% White + 30% Yellow Ochre + 20% Alizarin Crimson + 10% Payne's Gray	50% White + 10% Lemon Yellow + 40% Cobalt Blue Hue

SAGE	EUCALYPTUS GREEN	LEAF GREEN	MONSTERA	SMOG	HYDRANGEA BLUE

SLATE	MOODY BLUE	STONE	SOIL	BRANCH	LIGHT
30% White + 30% Oxide of Chromium + 40% Payne's Gray	50% Cobalt Blue Hue + 40% Payne's Gray + 10% Alizarin Crimson	20% White + 10% Oxide of Chromium + 20% Burnt Sienna + 30% Payne's Gray + 20% Ivory Black	25% Burnt Sienna + 25% Payne's Gray + 50% Ivory Black	40% Yellow Ochre + 50% Burnt Sienna + 10% Ivory Black	80% White + 20% Burnt Sienna

SLATE	MOODY BLUE	STONE	SOIL	BRANCH	LIGHT

LIGHT MEDIUM	LIGHT MEDIUM TAN	MEDIUM	MEDIUM TAN	TAN DEEP	DEEP
80% White + 15% Yellow Ochre + 5% Lemon Yellow	70% White + 30% Burnt Sienna (yes! This is the same as Light, just with MORE Burnt Sienna)	60% White + 10% Yellow Ochre + 5% Lemon Yellow + 25% Burnt Sienna	30% White + 15% Yellow Ochre + 5% Lemon Yellow + 40% Burnt Sienna + 10% Ivory Black	20% White + 10% Yellow Ochre + 5% Lemon Yellow + 45% Burnt Sienna + 15% Ivory Black + 5% Alizarin Crimson	15% White + 10% Yellow Ochre + 5% Lemon Yellow + 45% Burnt Sienna + 20% Ivory Black + 5% Alizarin Crimson

LIGHT MEDIUM	LIGHT MEDIUM TAN	MEDIUM	MEDIUM TAN	TAN DEEP	DEEP

LONG LEAF EUCALYPTUS

COLOR PALETTE:

Smog Buff Sage Slate Leaf Green

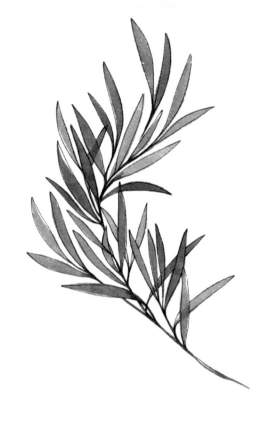

01. Using a waterproof pen, INK the design.

02. Decide how you'd like to treat your boundaries. The majority of this piece was painted using the "Defined Boundary" approach on page 21 to treat each leaf as its own boundary.

03. As you begin to paint, focus on one leaf at a time, so your boundaries stay wet as you paint each one. Work from top to bottom, filling in each leaf as you move down.

04. When you encounter a leaf overlapping another, only paint one, leaving a dry area as a barrier between wet boundaries. Keeping separate boundaries will allow each leaf to dry and not bleed into its neighbor. We will come back to these overlapping leaves in step 8 after the first ones are dry.

05. WASH your leaves, alternating between Smog, Buff, Sage, Slate, and Leaf Green using your Round 4.

06. You can use the WET-IN-WET technique to add high-to-low contrast near the base of the leaf, where it connects to the stem.

07. As you continue down the leaf branch, lightly WASH the branch and stems in Leaf Green. Use your Round 1 brush to connect the leaves to the branch, as the stems are very thin. When you switch to the Round 1 brush, feel free to use a thicker magic sauce than you were using with your leaves. Using the 50w/50p consistency here will help keep your paint lines narrow.

08. Once all your leaves are dry, go back to the top and paint the overlapping leaves. Use the WET-ON-DRY technique to fill in the overlapping areas. This will add a nice transparent leaf layer as you cross over several already-washed leaves.

COLOR RECIPES:

SMOG: 40% White + 30% Yellow Ochre + 20% Alizarin Crimson + 10% Payne's Gray
BUFF: 90% White + 10% Yellow Ochre
SAGE: 50% White + 20% Yellow Ochre + 30% Oxide of Chromium

SLATE: 30% White + 30% Oxide of Chromium + 40% Payne's Gray
LEAF GREEN: 20% Oxide of Chromium + 50% Burnt Sienna + 30% Payne's Gray

DAHLIA

Brushes Needed:
ROUND 4

COLOR PALETTE:

Blush

Dahlia Pink

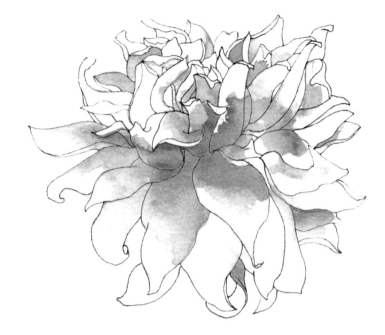

01. Using a waterproof pen, INK the design.

02. Decide how you'd like to treat your boundaries. The majority of this piece was wet at the same time, using the "Loose Boundary" approach on page 21 for a more free-flowing look.

03. WASH Blush in the areas where you would like to add color.

04. RESERVE some areas of the flower petals, so just the white of the paper shines through. Leaving the ends of petals with the brightest highlights will give you the most realistic look.

05. With Dahlia Pink, use WET-IN-WET to deepen some of the flower's petals, letting the darker color blend and bleed.

COLOR RECIPES:

BLUSH: 50% White + 30% Yellow Ochre + 20% Alizarin Crimson
DAHLIA PINK: 10% White + 19% Yellow Ochre + 30% Alizarin Crimson + 40% Burnt Sienna + 1% Ivory Black

ROUND LEAF EUCALYPTUS

Brushes Needed:
ROUND 1 & 4

COLOR PALETTE:

Leaf Green

Slate

Sage

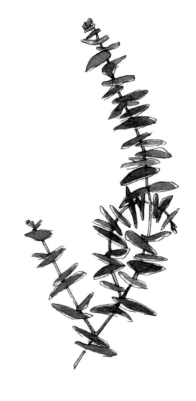

01. Using a waterproof pen, INK the design.

02. Decide how you'd like to treat your boundaries. The majority of this piece was painted using the "Defined Boundary" approach on page 21 to treat each leaf as its own boundary.

03. As you begin to paint, focus on one leaf at a time, so your boundaries stay wet as you paint each one. Work from top to bottom, filling in each leaf as you move down the branch.

04. When you encounter a leaf that is overlapping another, only paint one, leaving the dry area as a barrier between wet boundaries. Keeping separate boundaries will allow each leaf to dry and not bleed into its neighbor. (This also helps avoid the dreaded "leaf-blob" effect, where a leaf gets flooded and just keeps growing and growing.) We will come back to these overlapping leaves in step 7 after the first ones are dry.

05. WASH your leaves, alternating between Leaf Green, Slate, and Sage using your Round 4. RESERVE the edges of the leaves to get the highlighted effect I have in my icon. Notice, some smaller boundary leaves in your piece may need your

Round 1, where larger boundary leaves need your Round 4.

06. As you continue down the leaf branch, lightly WASH the branch and stems in Leaf Green as you go using your Round 1 brush. When you switch to the Round 1 brush, feel free to use a thicker magic sauce than you were using with your leaves. Using the 50w/50p consistency here will help keep your paint lines narrow.

07. Once you've painted all of the leaves that are not overlapping, go back to the top and paint the overlapping leaf areas to finish up your cider gum eucalyptus.

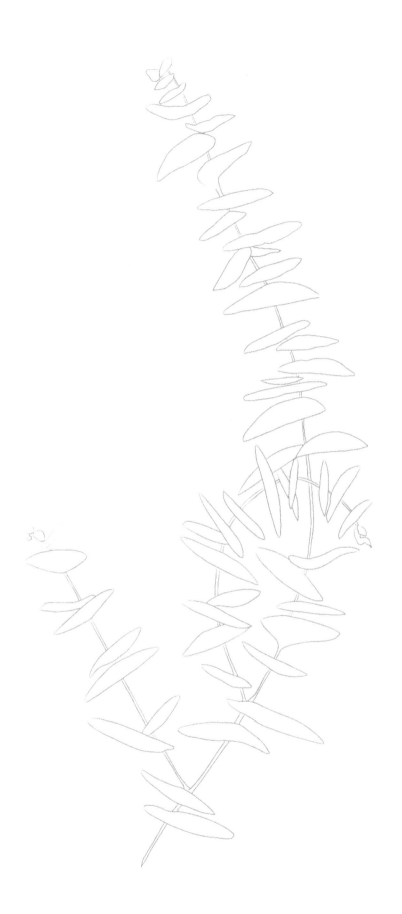

COLOR RECIPES:

LEAF GREEN: 20% Oxide of Chromium + 50% Burnt Sienna + 30% Payne's Gray
SLATE: 30% White + 30% Oxide of Chromium + 40% Payne's Gray
SAGE: 50% White + 20% Yellow Ochre + 30% Oxide of Chromium

FOXGLOVE

Brushes Needed:
ROUND 1 & 4

COLOR PALETTE:

Burnt Rose | Perylene Maroon | Alizarin Crimson | Stone | Slate | Sage

01. Using a waterproof pen, INK the design.

02. Decide how you'd like to treat your boundaries. The majority of this piece was painted using the "Defined Boundary" approach on page 21 to treat each flower as its own boundary.

03. As you begin to paint, focus on one flower at a time, so your wet boundaries stay wet as you paint each floral. I suggest starting at the top of the stem, filling in each flower as you work your way down. When you encounter a flower that is overlapping another, only paint one, leaving a dry flower as a barrier between wet flower boundaries. Keeping separate boundaries will allow each flower to dry and not bleed into its neighbor. We will go back to paint the areas we left dry once the surrounding wet boundaries have dried.

04. WASH your first flower in Burnt Rose using your Round 4.

05. As you can see from the project icon, you'll want some lovely highlights in these flowers. To achieve this, you can either RESERVE some areas without paint, so the white of the paper shows through, or you can WASH each flower completely and BLOT out light areas using your paper towel.

06. Use WET-IN-WET to deepen the color of the petals, alternating between Perylene Maroon and Alizarin Crimson. Use the deeper-toned colors sparingly and closer to the center of the flowers, where the base connects to the stem, and keep the tips of the petals lighter. You may prefer to switch to your Round 1 to add your WET-IN-WET details.

07. Paint all of your flowers following steps 3 through 5.

08. Now, it's time for the leaves! As you can see in the icon, I chose to leave my leaves the white of the page. If you'd like to add colors, though, I'd suggest alternating between three darker-toned colors: Stone, Slate, and Sage. Make sure your flowers are dry first, then use a simple WASH for each leaf.

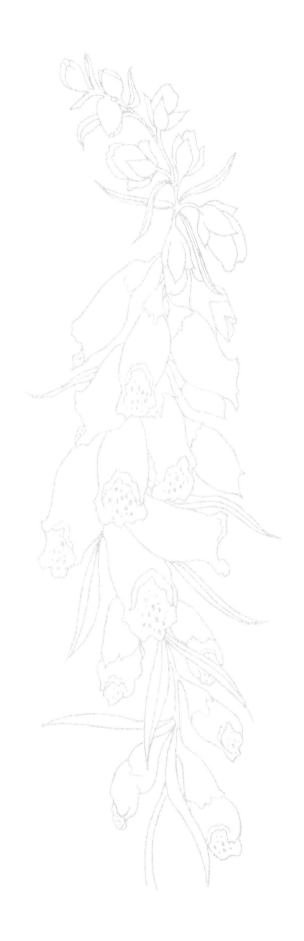

COLOR RECIPES:

BURNT ROSE: 35% Burnt Sienna + 60% Alizarin Crimson + 5% Ivory Black
PERYLENE MAROON SUBSTITUTE: 39% Burnt Sienna + 60% Alizarin Crimson + 1% Ivory Black
STONE: 20% White + 10% Oxide Of Chromium + 20% Burnt Sienna + 30% Payne's Gray + 20% Ivory Black

SLATE: 30% White + 30% Oxide of Chromium + 40% Payne's Gray
SAGE: 50% White + 20% Yellow Ochre + 30% Oxide Of Chromium

BUTTERCUP WREATH

Brushes Needed:
ROUND 1 & 4

COLOR PALETTE:

Lemon Yellow Sunrise Pea Green Oxide of Chromium

Sage Smog Payne's Gray

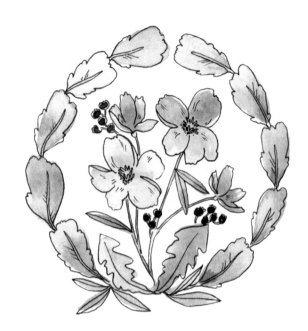

01. Using a waterproof pen, INK the design.

02. Decide how you'd like to treat your boundaries. The majority of this piece was wet at the same time, using the "Loose Boundary" approach on page 21 for a more free-flowing look.

03. WASH the buttercup flowers in Lemon Yellow and Sunrise.

04. While your buttercups dry, move to your leaves. WASH the leaves alternating between Pea Green, Oxide of Chromium, and Sage.

05. While you're working with your green palette, grab your Round 1 brush and lightly WASH the stems and leaves in the center with Pea Green.

06. With your Round 4 brush, WASH the other central flowers in Smog.

07. Pick up your Payne's Gray with your Round 1 brush and, using WET-ON-DRY, make small dabs inside the berries. Remember, because the berries are a smaller boundary, the consistency on your palette is 50w/50p.

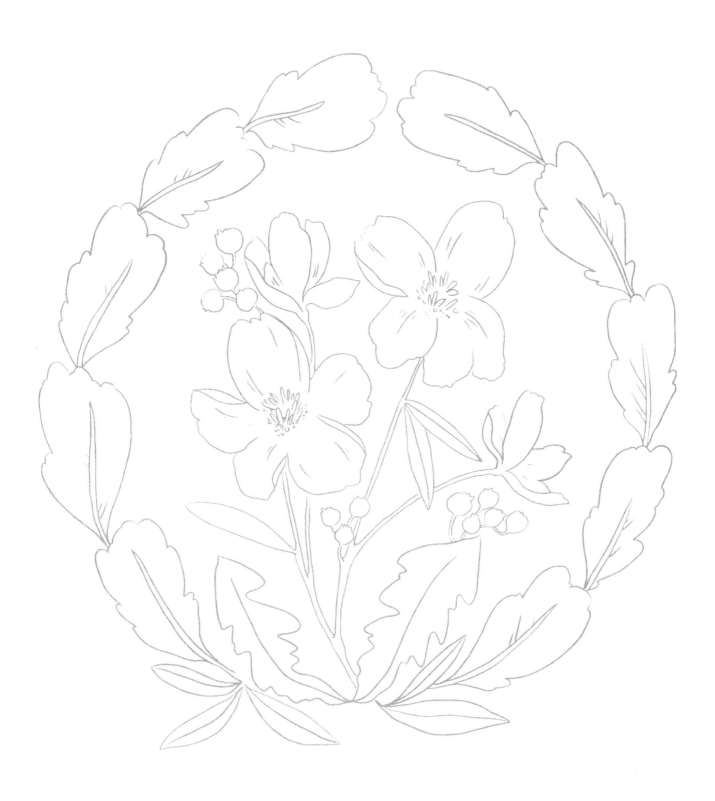

COLOR RECIPES:

SUNRISE: 10% White + 80% Yellow Ochre + 10% Alizarin Crimson
PEA GREEN: 70% Yellow Ochre + 30% Oxide of Chromium
SAGE: 50% White + 20% Yellow Ochre + 30% Oxide of Chromium
SMOG: 40% White + 30% Yellow Ochre + 20% Alizarin Crimson + 10% Payne's Gray

FIDDLE LEAF FIG

Brushes Needed:
ROUND 1 & 4

COLOR PALETTE:

Seashell Pea Green Sage Oxide of Chromium Branch

01. Using a waterproof pen, INK the design.

02. Decide how you'd like to treat your boundaries. The majority of this piece was painted using the "Defined Boundary" approach on page 21 to treat each leaf as its own boundary.

03. WASH your plant's pot in Seashell with your Round 4.

04. Use WET-IN-WET to dab in more Seashell to deepen the color of the pot near the top.

05. As you begin to paint the plant, focus on one leaf at a time, so your wet boundaries stay wet as you paint each one. Work from top to bottom, filling in each leaf with a WASH as you move down. When you encounter a leaf that is overlapping another, only paint one, leaving a dry leaf as a barrier between wet leaf boundaries. You will come back to paint in any empty boundaries once the surrounding leaves are dry. Keeping separate boundaries will allow each leaf to dry and not bleed into its neighbor.

06. Now, paint your leaves following steps 6 and 7.

07. WASH the leaves in alternating colors of Pea Green and Sage.

08. Apply WET-IN-WET in each leaf as you go using Oxide of Chromium. Add the darker color where the leaf attaches to the stem.

09. While your leaves are drying, pick up your Branch color. Use the WET-ON-DRY technique with your Round 1 to paint the trunk of your Fiddle Leaf Fig tree, gently attaching the trunk to the stems of the leaves.

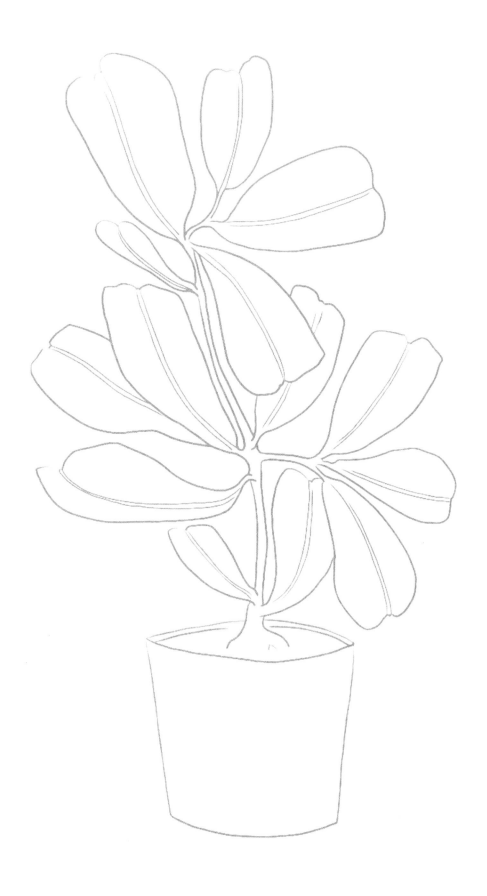

COLOR RECIPES:

SEASHELL: 70% White + 20% Yellow Ochre + 10% Alizarin Crimson
PEA GREEN: 70% Yellow Ochre + 30% Oxide of Chromium
SAGE: 50% White + 20% Yellow Ochre + 30% Oxide of Chromium
BRANCH: 40% Yellow Ochre + 50% Burnt Sienna + 10% Ivory Black

WILDFLOWER SWAG

Brushes Needed:
ROUND 4

COLOR PALETTE:

Perylene Maroon

Sunrise

Alizarin Crimson

Sage

Payne's Gray

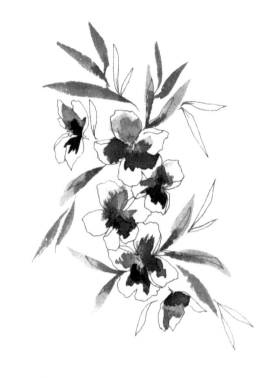

01. Using a waterproof pen, INK the design.

02. Decide how you'd like to treat your boundaries. The majority of this piece was painted using the "Undefined Boundary" approach on page 22.

03. Focus on one flower at a time, so your wet boundaries stay wet as you paint each floral. Work from top to bottom, filling in each flower as you move down. Following the icon, leave ample white space in each flower—RESERVE the white of the paper, so it acts as a highlight in each flower.

04. Start at the top of your piece and WASH the first flower in select parts of the petals in Perylene Maroon.

05. While the wash is still wet, use a paper towel to BLOT out sections of the wash. You can refer to the icon to see where I used this technique.

06. Again, while the petal wash is still wet, use WET-IN-WET to alternate dropping in Sunrise and Alizarin Crimson to your petals. For a more concentrated and deeper color in your petals, drop in Perylene Maroon as well. For this technique, remember that using the magic sauce of 50w/50p is going to give you this heavier saturation of color.

07. Continue painting the rest of the flowers, one by one, following steps 4 through 6.

08. WASH some leaves, alternating between Sage and Payne's Gray.

09. While your Sage leaves are still wet, Use WET-IN-WET to drop in Payne's Gray to tie the leaves together.

10. You'll notice in the icon that some of the leaves are not painted, while other leaves are painted, but do not have a black outline. This is your invitation to have fun and play!

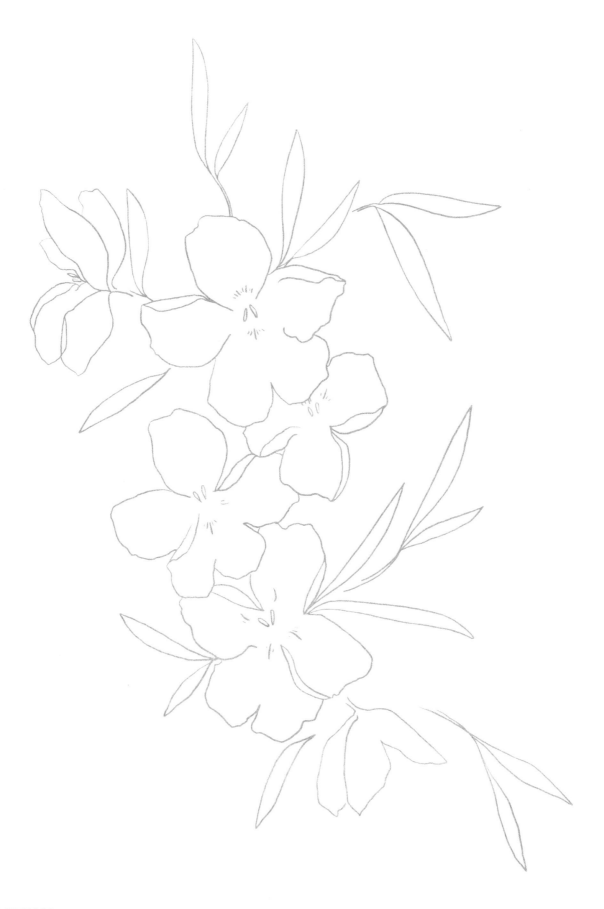

COLOR RECIPES:

PERYLENE MAROON SUBSTITUTE: 39% Burnt Sienna + 60% Alizarin Crimson + 1% Ivory Black
SUNRISE: 10% White + 80% Yellow Ochre + 10% Alizarin Crimson
SAGE: 50% White + 20% Yellow Ochre + 30% Oxide of Chromium

DAISIES

COLOR PALETTE:

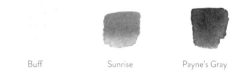

Buff Sunrise Payne's Gray

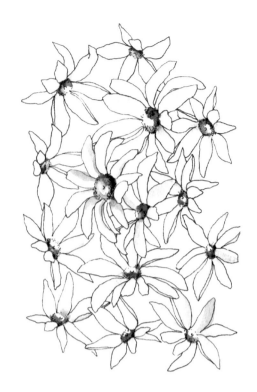

01. Using a waterproof pen, INK the design.

02. Decide how you'd like to treat your boundaries. The majority of this piece was painted using the "Defined Boundary" approach on page 21.

03. Take a look at the icon and notice that each petal is not completely painted in; in fact, I used just one brushstroke per petal, and it's a very light wash. You can choose to color them in this way, by RESERVING the white of the paper, or you can wash the entire petal. It's up to you!

04. Start at one end of your piece and, using just one paint brush stroke per petal, add a WASH of Buff to the side of each petal, going flower by flower, with your Round 4. Pro tip: Rotate your workbook around as you work, so you don't have to worry about dragging your hand through wet petals!

05. Now we'll do the flower centers one at a time. Using just water, WASH your first flower center. As with the petals, you don't need to cover the entire center; try making a "c" or "o" shape wet WASH in each center. Switching to your Round 1 and using the thicker consistency of 50w/50p for the smaller center washes will be easier.

06. When your first flower center is wet with movement and shine, continue using your Round 1 brush and use WET-IN-WET to add a drop of Sunrise into the small wet boundary, and then a drop of Payne's Gray.

07. Continue to paint the centers of your flowers using steps 4 through 5.

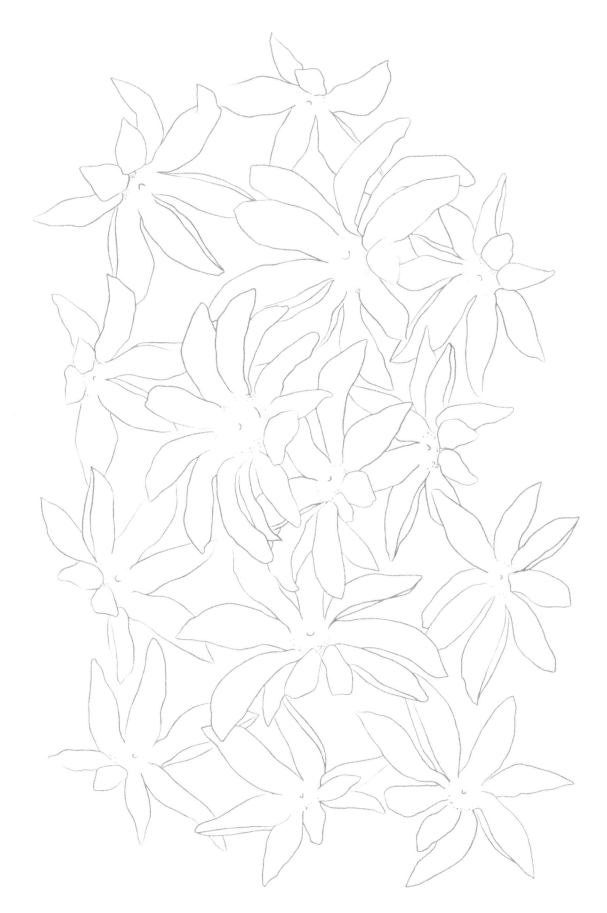

COLOR RECIPES:

BUFF: 90% White + 10% Yellow Ochre
SUNRISE: 10% White + 80% Yellow Ochre + 10% Alizarin Crimson

LADY ROSE

Brushes Needed:
ROUND 1 & 4

COLOR PALETTE:

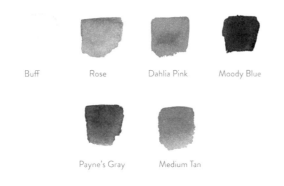

Buff Rose Dahlia Pink Moody Blue

Payne's Gray Medium Tan

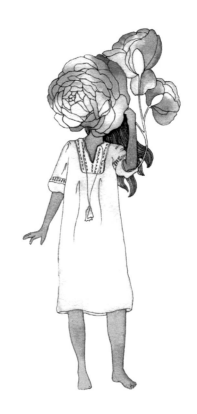

01. Using a waterproof pen, INK the design.

02. Decide how you'd like to treat your boundaries. I used the "Defined Boundary" approach on page 21 to paint inside my inked lines for everything but the roses. The roses use the "Loose Boundary" approach.

03. WASH the dress in Buff using your Round 4.

04. As you paint the roses in steps 5 through 7, you'll begin with the smallest rose flower on the right and work your way up to the large flower covering Lady Rose's face.

05. WASH the entire small rose on the right in the color Rose.

06. Using WET-IN-WET and your Round 1, add in dabs of Dahlia Pink on the petals closest to the stem.

07. While the flower is wet, use the DRY BRUSH technique to sweep away any high concentration of color from the top edges of the flower to create a high-to-low contrast within the wet flower boundary. You can also use your paper towel to gently BLOT away excess water or paint to create highlights.

08. Once the smallest rose is dry, move to the center rose and follow steps 5 through 7. I concentrated the most saturated color on the right side of the flower and left the left side lighter (as you can see in the icon). I did this to give more definition to the largest rose, but do whatever feels best for you!

09. Once the center rose is dry, move to the largest rose and follow steps 5 through 7. Wait for this rose to dry before moving on to step 10.

10. WASH Lady Rose's hair in Moody Blue.

11. Using WET-IN-WET and your Round 1, add Payne's Gray in the hair close to Lady Rose's head.

12. While the hair is still wet, use the DRY BRUSH technique to sweep away any high concentration of color from the bottom edges of her hair to create a high-to-low contrast. You can also use your paper towel to gently BLOT away excess water or paint to create highlights.

13. If you'd like any of the individual petals on the roses to stand out, you can return to them and use the WET-ON-DRY technique to add another layer of translucent color in Dahlia Pink. This will make those individual petals darker and deeper in color.

14. Once all of your washes are dry, you may add skin tone if you'd like. I used Medium Tan; feel free to paint in Lady Rose with any skin tone you prefer using the skin tone recipes on page 27.

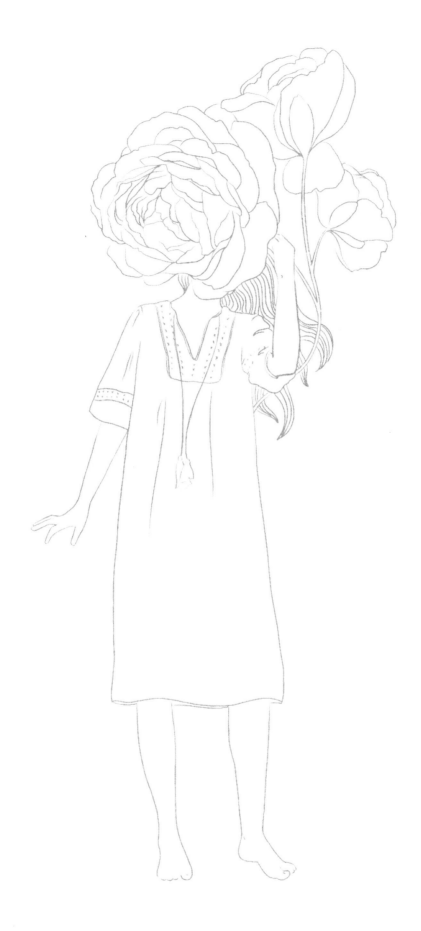

COLOR RECIPES:

BUFF: 90% White + 10% Yellow Ochre

ROSE: 10% White + 40% Yellow Ochre + 50% Alizarin Crimson

DAHLIA PINK: 10% White + 19% Yellow Ochre + 30% Alizarin Crimson + 40% Burnt Sienna + 1% Ivory Black

MOODY BLUE: 50% Cobalt Blue Hue + 40% Payne's Gray + 10% Alizarin Crimson

MEDIUM TAN: 30% White + 15% Yellow Ochre + 5% Lemon Yellow + 40% Burnt Sienna + 10% Ivory Black

FRUIT BLOSSOMS

Brushes Needed:
ROUND 4

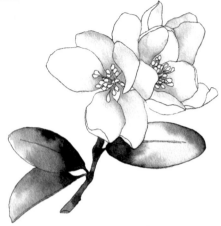

COLOR PALETTE:

Blush

Payne's Gray

Branch

01. Using a waterproof pen, INK the design.

02. Decide how you'd like to treat your boundaries. I used the "Loose Boundary" approach on page 21 for a more free-flowing look.

03. To achieve very light petals for this piece, you will use just water for your washes! So, beginning at the top of the plant, WASH your first few petals in clear water.

04. Focus on painting a few petals at a time, so your wet boundaries stay wet as you paint each grouping of petals. Work from top to bottom, washing 3-4 petals at a time as you move down the plant. RESERVE the smaller boundaries in the center of the flower to keep those the white of the page.

05. While your petals are wet, use WET-IN-WET to add dabs of Blush using your thicker magic sauce consistency of 50w/50p, close to where the petals connect in the center of the flower. Continue to dab in Blush to build color in your wet petals until you achieve the saturation you like.

06. While your petals are still wet, use the DRY BRUSH technique to sweep away any high concentration of color to create a high-to-low contrast. You can also use your paper towel to gently BLOT away excess water or paint to create highlights.

07. Continue to paint your petals, moving down the plant and following steps 4 through 6. Your petal groupings will bleed together if wet boundaries overlap, which is fine for this piece since your petals are all painted in the same color.

08. Now it's time for the leaves! Make sure your petals are dry

(otherwise, your Payne's Gray will bleed easily into your light Blush petals if the wet boundaries touch!), and then start with the very bottom leaf and work your way up.

09. Using just water, WASH the entire boundary of the bottom leaf.

10. Using WET-IN-WET, dab in Payne's Gray where the leaf connects to the stem, dabbing at least three or four times to really deposit that lovely blue.

11. Again, using WET-IN-WET, dab in Blush near the edge of the leaf, letting that light color blend with the gray-blue of the Payne's Gray. Let the colors swirl and the water evaporate without interfering too much with your paintbrush. These leaves can lose much of their natural watercolor beauty if they are fussed with too much!

12. Let your first leaf dry before overlapping wet boundaries. Paint the leaf closest to this bottom one next, following steps 9 through 11.

13. Paint the top leaf next, following steps 9 through 11 (after confirming that the overlapping fruit tree petal is completely dry!).

14. WASH the fruit tree stem in Branch.

15. Use WET-IN-WET to drop in Payne's Gray near where the leaves connect to add continuity to your piece.

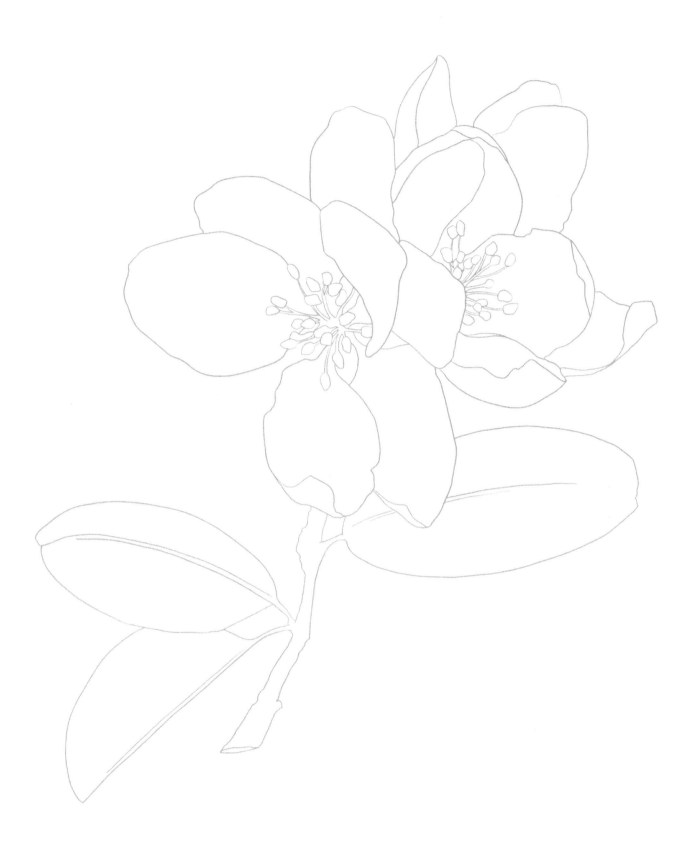

PEONY & LILAC SWAG

Brushes Needed:
ROUND 1 & 4

COLOR PALETTE:

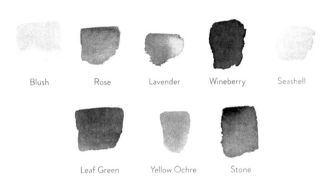

Blush Rose Lavender Wineberry Seashell

Leaf Green Yellow Ochre Stone

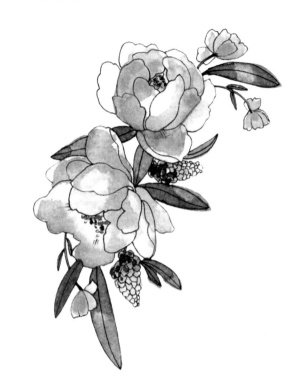

01. Using a waterproof pen, INK the design.

02. Decide how you'd like to treat your boundaries. The majority of this piece was painted using the "Loose Boundary" approach on page 21.

03. As you begin to paint, focus on one flower at a time, so your boundaries stay wet as you paint each one. I suggest starting with the larger flowers and working your way around to the smaller ones.

04. For your first large flower, using your Round 4, WASH the petals alternating between Blush and Rose. RESERVE some areas of the petal with just the white of the paper showing through; these will be lovely highlighted points on each flower. (You can also use a paper towel to BLOT out light areas instead, or you can DRY BRUSH.)

05. Use WET-IN-WET to deepen the color of some of the flower's petals, alternating between Rose and Lavender. Use these deeper-toned colors sparingly, starting with the base of the petal and leaving the tips lighter.

06. Move to the next large flower and repeat steps 3 and 4.

07. For the smaller purple florals, WASH both in Lavender and let your washes dry completely. Use WET-ON-DRY, and your Round 1, to add small dabs of Wineberry for more definition.

08. WASH the remaining three small flowers in Seashell and let your washes dry completely. Use the WET-ON-DRY technique to add small dabs of brighter color in Seashell.

09. WASH your leaves, alternating between Stone and Leaf Green. If any of your flowers are still wet, make sure not to overlap wet boundaries, so the leaves don't bleed into the light petals.

10. Using the WET-ON-DRY technique and your Round 1, paint in the narrow leaves and stems using the thicker consistency magic sauce of 50w/50p, in Leaf Green.

11. Using the WET-ON-DRY, add small dabs of Yellow Ochre and Stone to the centers of the flowers to accent their contrasting centers.

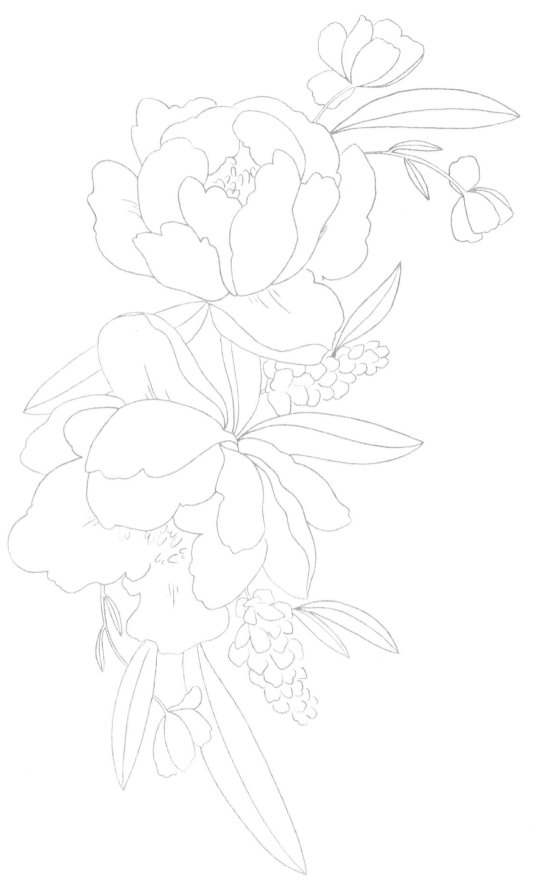

COLOR RECIPES:

BLUSH: 50% White + 30% Yellow Ochre + 20% Alizarin Crimson

ROSE: 10% White + 40% Yellow Ochre + 50% Alizarin Crimson

LAVENDER: 10% White + 5% Yellow Ochre + 45% Payne's Gray + 40% Alizarin Crimson

WINEBERRY: 80% Perylene Violet + 20% Payne's Gray

SEASHELL: 70% White + 20% Yellow Ochre + 10% Alizarin Crimson

LEAF GREEN: 20% Oxide of Chromium + 50% Burnt Sienna + 30% Payne's Gray

STONE: 20% White + 10% Oxide Of Chromium + 20% Burnt Sienna + 30% Payne's Gray + 20% Ivory Black

LUPINE

Brushes Needed:
ROUND 1 & 4

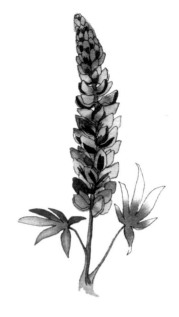

COLOR PALETTE:

Lavender Wineberry Pea Green Olive Green

01. Using a waterproof pen, INK the design.

02. Decide how you'd like to treat your boundaries. The majority of this piece uses the "Loose Boundary" approach on page 21.

03. Begin at the top of your plant and, using a WASH of Lavender, cover the first top third of your petals using your Round 4. (We'll come back to add some definition to these petals in steps 14 through 15.)

04. While this top section is still wet, move to the middle section of your plant and continue this WASH of Lavender. Use your brush to blend the top wash with the middle wash by overlapping their wet boundaries You can choose to stay within your inked boundaries or move beyond them.

05. Pick up your Round 1 brush and use WET-IN-WET to drop in Wineberry to add points of deeper color near the stem, within the wet wash, and where the flower connects.

06. While this boundary is still wet, use WET-IN-WET to drop in Pea Green near the center on the stem of the plant. Because the entire flower boundary is wet, the green will bleed and firework into the flowers nearby.

07. Repeat steps 4 through 6 to paint the bottom third of the flower petals. Let these flower washes dry before moving on to paint the stem and leaves.

08. Using just water, WASH the entire boundary of the left leaf.

09. Using WET-IN-WET, dab in Pea Green and Olive Green, alternating between the two colors. Remember, with WET-IN-WET, wherever you lift your paintbrush, you leave the highest saturation of color. So, wherever you would like the deepest color, drop in paint and lift your paintbrush there.

10. Using your Round 1, connect the wet leaf boundary to the stem by painting a WASH of Olive Green to cover the stem.

11. Move from the left leaf stem to the center branch and WASH in Olive Green.

12. Move into the adjoining stem and leaf on the right by painting a WASH of Pea Green on this stem, using your paintbrush to cross the stem boundaries while they are still wet.

13. Repeat steps 10 through 12 to paint the right leaf boundary.

14. Check to see if the wash on your flowers is dry. If so, it's time to add your WET-ON-DRY details. Pro tip: Keep using your Round 1 brush for these details. It will allow you to soak up less water and apply a more concentrated layer of paint.

15. Starting at the top of your flower, use WET-ON-DRY in Wineberry (remember your thicker magic sauce 50w/50p consistency) to make small markings on your petals near where they connect to the stem. Work your way down the flower, referencing the icon for placement. Or, do your own placement here, and relish the creative opportunity!

16. For finishing touches, feel free to add WET-ON-DRY strokes to your stem in Pea Green for a nice translucent layer of color and added depth.

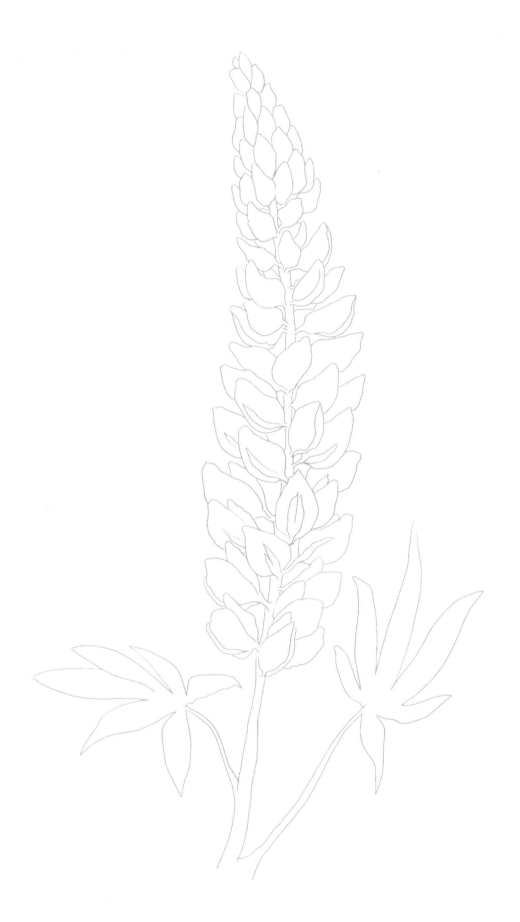

COLOR RECIPES:

LAVENDER: 10% White + 5% Yellow Ochre + 45% Payne's Gray + 40% Alizarin Crimson
WINEBERRY: 80% Perylene Violet + 20% Payne's Gray
PEA GREEN: 70% Yellow Ochre + 30% Oxide of Chromium
OLIVE GREEN: 40% Oxide of Chromium + 60% Burnt Sienna

HELLEBORE

Brushes Needed:
ROUND 1 & 4

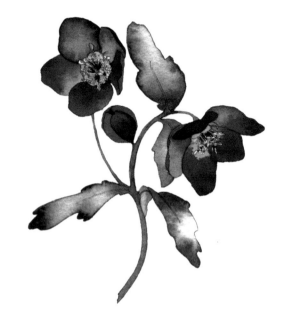

COLOR PALETTE:

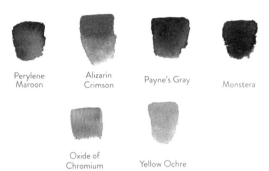

Perylene Maroon

Alizarin Crimson

Payne's Gray

Monstera

Oxide of Chromium

Yellow Ochre

01. Using a waterproof pen, INK the design.

02. Decide how you'd like to treat your boundaries. I chose to use the "Defined Boundary" approach on page 21 to treat each flower petal and leaf as its own boundary.

03. When painting in a "Defined Boundary" style, one wet boundary cannot touch another; otherwise, the boundaries will bleed and blend for a totally different look. So, we will "hopscotch" around the piece, only painting petals that have dry neighbors. Each petal then becomes its own little painting, and you can try different methods within each to create an interesting collection of petals. Steps 4 through 8 provide ideas for methods to try; you do not need to do all of these in every petal (or leaf)!

04. WASH your first petal in Perylene Maroon using your Round 4 brush.

05. Using WET-IN-WET, drop in alternating dabs of Alizarin Crimson and Perylene Maroon to add points of depth.

06. While the petal is wet with movement and shine, use the DRY BRUSH technique to sweep away any high concentration of color or to create a highlighted area. You can also use your paper towel to gently BLOT away excess water or paint to create highlights.

07. While the petal is still wet, use WET-IN-WET to drop in clear wash water. The water will push the wet paint pigment to the edges of your petal boundaries, creating beautiful veining

fireworks within this petal. Once you drop in the water, try not to fuss with it too much; this effect is most beautiful when left to do its thing. You may use your paper towel to BLOT out excess water if needed.

08. Once a petal is dry, you can use WET-ON-DRY to add another layer of a wet WASH to deepen the color and make it stand out.

09. Once you are out of petals with dry neighbors, move onto your leaves and follow the same method you used for the petals in steps 4 through 8. For the leaves, alternate between Payne's Gray, Monstera, and Oxide of Chromium. (Remember, you don't have to do all of the methods for each petal or leaf; try to make each one unique!)

10. Once all of your petals are completely dry, it's time to paint the centers of your flower and the stems. Switch to your Round 1 as these are small boundaries. You will not be using much water, and you want a higher concentration of paint, a 50w/50p consistency. For the centers, use the colors Payne's Gray, Yellow Ochre, and Oxide of Chromium and very lightly paint the centers of the flowers. Use a paper towel to BLOT any excess water that may bubble on the surface. For the stems, use your Round 1 and the same thicker magic sauce, in Monstera.

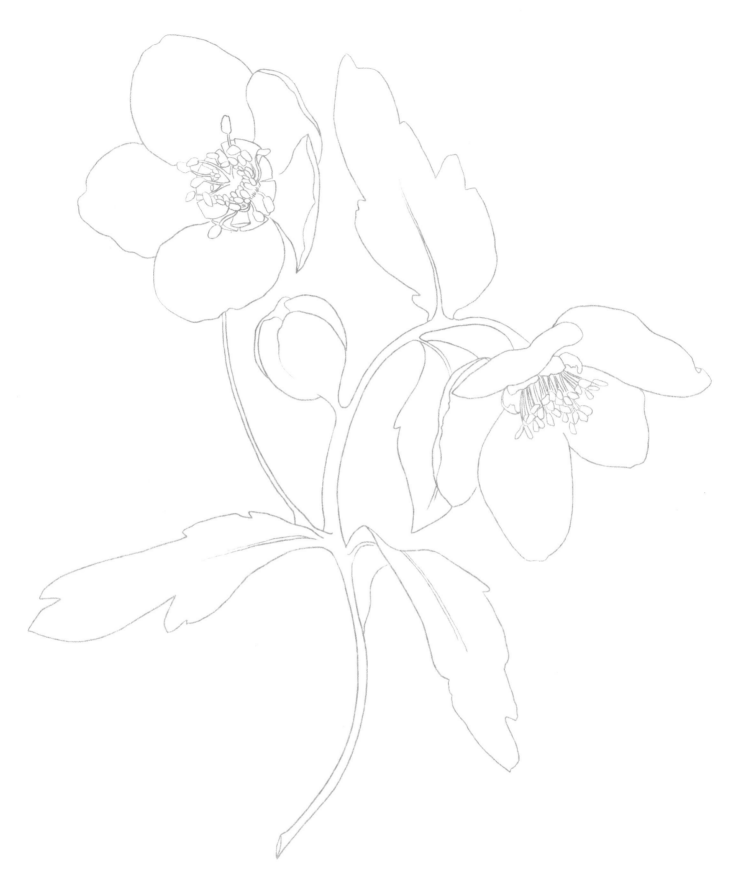

COLOR RECIPES:

PERYLENE MAROON SUBSTITUTE: 39% Burnt Sienna + 60% Alizarin Crimson + 1% Ivory Black
MONSTERA: 60% Oxide of Chromium + 40% Payne's Gray

PEONY & WILDFLOWERS

Brushes Needed:
ROUND 1 & 4

COLOR PALETTE:

Buff Burnt Sienna Payne's Gray Branch Yellow Ochre

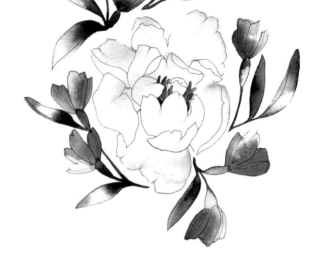

01. Using a waterproof pen, INK the design.

02. Decide how you'd like to treat your boundaries. I chose to use the "Loose Boundary" approach on page 21. Pro tip: To get this beautiful high-to-low contrast in your botanical elements, it's best to start with a clear wash. I like to work from lightest to darkest in color saturation to save trips to refill my water. In order to work with wet wash areas efficiently, it makes sense to only wet a few petals at a time. Wet three to four petals at once, complete step 4 for these wet petals, and then WASH several more petals at once. It's OK if these peony petal boundaries overlap, as they are all the same color. But breaking this flower into petal boundaries will help, since the boundaries are large.

03. Start with your Round 4 brush. Using just water, WASH your center peony. Using WET-IN-WET, begin to build a light color in each petal by dabbing in Buff. Use your paintbrush to sweep the color into the petals if it needs a bit of encouragement to move. Use the DRY BRUSH technique to sweep away any high concentration of color. You can also use your paper towel to gently BLOT away excess water or paint to create highlights. Don't worry about the center details for now—we'll save those for last!

04. Using just water, WASH your first wildflower and use WET-IN-WET to dab in Burnt Sienna near the base of the flower. Continue to slowly dab in color to increase the saturation. Use the DRY BRUSH technique to sweep away color from edges of some petals to create the lovely high-to-low saturated look. Paint the rest of your wildflowers following this step, rotating your workbook as you work to best access each flower.

05. By the time you've painted the last wildflower, your first should be dry. Now it's time to paint the foliage. Follow step 4 but this time, use Payne's Gray on your leaves and buds. Pro tip: For the smaller stems, switch to your Round 1 brush and draw the wet Payne's Gray mixture down into the thinner boundaries. Don't worry too much about staying inside the lines—worrying about perfection is never freeing or fun. Remember, flowers in nature aren't perfect, so don't expect your artistic pieces of them to be perfect either.

06. Lastly, let's go back to the peony center. Use WET-ON-DRY (remember your thicker 50w/50p consistency) to make small brush marks in Branch, Yellow Ochre, and Burnt Sienna.

COLOR RECIPES:

BUFF: 90% White + 10% Yellow Ochre
BRANCH: 40% Yellow Ochre + 50% Burnt Sienna + 10% Ivory Black

LADY SWEET PEA

Brushes Needed:
ROUND 1 & 4

COLOR PALETTE:

Sunrise Tan Deep Ivory Black Buff

Moody Blue Burnt Rose Dahlia Pink

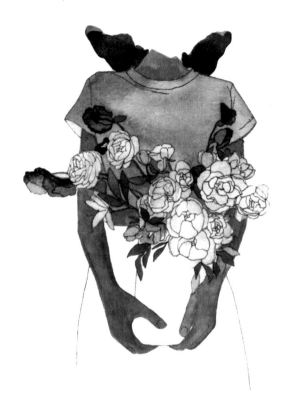

01. Using a waterproof pen, INK your design.

02. Decide how you'd like to treat your boundaries. The florals of this piece were painted using the "Loose Boundary" approach on page 21, and Lady Sweet Pea's details were painting using the "Defined Boundary" approach. Pro tip: When working in pieces that have repeats of a similar flower, I like to paint all of them at the same time before moving onto a different type of flower. This keeps the palette mixing to a minimum. This piece is unique because it is a bouquet made up of only two types of flowers: sweet peas and roses. You'll also notice something else about this bouquet: no green! Leaving out this "integral" color is a fun way to challenge your concept of florals. I absolutely love the effect.

03. WASH Lady Sweet Pea's shirt in Sunrise. Use your Round 4 for larger boundaries in this piece, and feel free to switch to your Round 1 for more detailed areas. Use WET-IN-WET to dab in more Sunrise to add dimension to the shirt, and your DRY BRUSH to sweep away any high concentration of color and create subtle highlights.

04. While her shirt dries, WASH her hair in Tan Deep, and use WET-IN-WET to dab in Ivory Black. Pro tip: Now is a good time to check your water and give it a rinse so you can paint

those lighter roses next.

05. Once her shirt is dry, let's paint those romantic garden roses! WASH a few roses using just water. Then use WET-IN-WET to sparingly dab in Buff. Follow this process as you color all the roses. In the icon, there are a few loose roses that have a slight lavender tinge; you can achieve this by using WET-IN-WET to add just a touch of Moody Blue (a little goes a long way, so be ready with your paper towel!).

06. With your Round 1 brush, WASH your leaves in Burnt Rose and Dahlia Pink. Alternate the concentration ratios here to get varying shades of color. You can also alternate the amount of water-to-paint ratio in your leaves as well. For some, you can use more water and less paint, and for other leaves, WASH in almost all paint and barely any water. See how the color changes!

07. WASH your last florals, your sweet peas, in Dahlia Pink, and use WET-IN-WET to dab in Moody Blue along the edges.

08. Once all of your washes are dry, it's time to paint in her skin tone if you'd like. For this project, I used Tan Deep for her skin color, but you may use any color from the skin tone recipes on page 27.

COLOR RECIPES:

SUNRISE: 10% White + 80% Yellow Ochre + 10% Alizarin Crimson

TAN DEEP: 20% White + 10% Yellow Ochre + 5% Lemon Yellow + 45% Burnt Sienna + 15% Ivory Black + 5% Alizarin Crimson

BUFF: 90% White + 10% Yellow Ochre

MOODY BLUE: 50% Cobalt Blue Hue + 40% Payne's Gray + 10% Alizarin Crimson

BURNT ROSE: 35% Burnt Sienna + 60% Alizarin Crimson + 5% Ivory Black

DAHLIA PINK: 10% White + 19% Yellow Ochre + 30% Alizarin Crimson + 40% Burnt Sienna + 1% Ivory Black

BLUEBERRY BRANCH

Brushes Needed:
ROUND 1 & 4

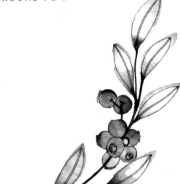

COLOR PALETTE:

Olive Green Branch Smog Cobalt Blue Hue Payne's Gray

01. Using a waterproof pen, INK the design.

02. Decide how you'd like to treat your boundaries. I painted the leaves using the "Loose Boundary" approach on page 21, with a little freedom to move outside of the lines, and the berries with the "Defined Boundary" approach.

03. As you begin to paint, focus on one leaf at a time, so your boundaries stay wet as you paint each one. Work from top to bottom, filling in each leaf as you move down the blueberry stem. We will come back to the berries—just focus on the leaves for now.

04. Beginning at the top of the plant, WASH your first leaf in Olive Green using your Round 4 brush.

05. While your leaf is still wet, pick up Branch with your Round 1 brush and use the WET-IN-WET technique to connect the end of the leaf to the stem.

06. Continue to WASH your leaves in Olive Green following steps 4 and 5. Skip the stems that overlap with the blueberries; we will come back to those.

07. Now it's time for the blueberries! You'll paint each berry separately to maintain defined boundaries. Once one berry is wet, hopscotch your way to the next berry that doesn't have a wet boundary as a neighbor. Come back and fill them in later when you are sure they won't bleed into their neighbors. Also, don't worry about the stems—you can paint over them in blue for now. We'll come back to make them brown and defined in step 12.

08. Starting at the top left, WASH the first berry in Smog. Depending on your comfort level and preference, feel free to switch to your Round 1 for the detailed parts of your piece.

09. Using WET-IN-WET, add in Cobalt Blue Hue and Payne's Gray to the berry.

10. While the berry is still wet, use the DRY BRUSH technique to sweep away any high concentration of color from the bottom of the berry to create a high-to-low contrast. You can also use your paper towel to gently BLOT away excess water or paint to create highlights in the berry.

11. Paint the rest of your berries following steps 8 through 10, hopscotching around and only painting berries that do not overlap with wet berries. Pro tip: If the berries do overlap, don't fret too much! They will just bleed together in color. You can go back once they are dry and individually define them using WET-ON-DRY. We will be doing this in the next step with the stems!

12. Once your berries are dry (remember the pro tip trick you learned on page 13, or just wait an hour or so to ensure they are completely dry), pick up Branch with your Round 1 and use WET-ON-DRY to paint the small stems on and around the berries in Branch. Pro tip: Remember your thicker 50w/50p consistency whenever you use the WET-ON-DRY for small details.

13. Go back and define any berries with Cobalt Blue Hue as needed using WET-ON-DRY. This helps if some of your berry boundaries have blended. It's also a way to make some berries darker and deeper in color for added contrast in your piece.

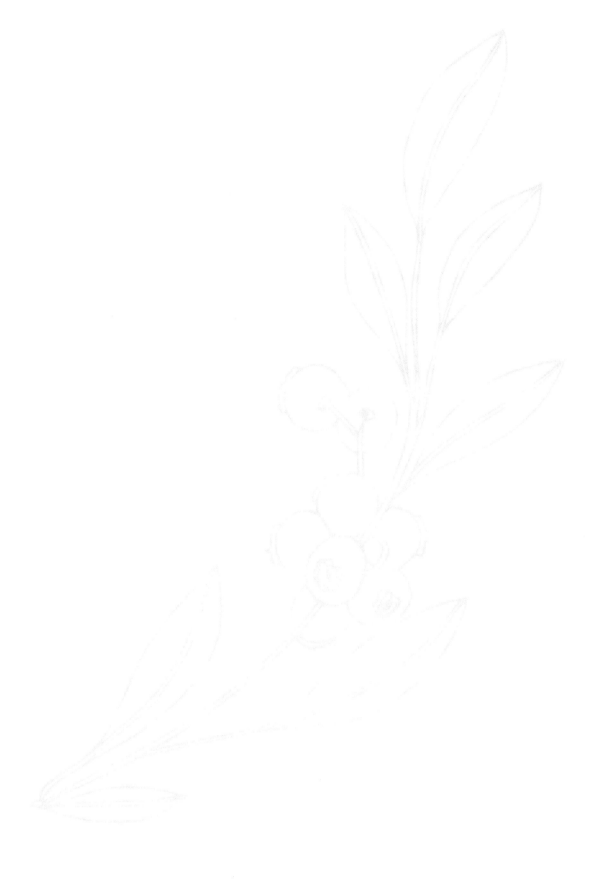

COLOR RECIPES:

OLIVE GREEN: 40% Oxide of Chromium + 60% Burnt Sienna
BRANCH: 40% Yellow Ochre + 50% Burnt Sienna + 10% Ivory Black
SMOG: 40% White + 30% Yellow Ochre + 20% Alizarin Crimson + 10% Payne's Gray

POPPIES

Brushes Needed:
ROUND 1 & 4

COLOR PALETTE:

Blush Oxide of Chromium Monstera Payne's Gray Taupe

01. Using a waterproof pen, INK the design.

02. Decide how you'd like to treat your boundaries. I chose to use the "Defined Boundary" approach on page 21 to treat each flower petal as its own boundary.

03. WASH both partially closed flower bud centers in Blush using your Round 4 brush.

04. Beginning at the top of the page, select a flower petal and WASH it in Blush. On some petals, let the white of the paper show through on the petal edges—RESERVE the painted boundary before the inked outline—to give the illusion of light on the petals. Hopscotch to the next petal, choosing one that has no wet boundaries surrounding it, and repeat this step. Continue to repeat this step until all of your petals have a nice light wash of Blush.

05. WASH the outer leaves of the top flower bud in Oxide of Chromium, and use WET-IN-WET to dab in Monstera to deepen the color. Use the DRY BRUSH technique to sweep away any concentrated color and use your paper towel to BLOT away excess water and paint to create highlights and points of light. Use your Round 1 brush to paint and continue a thin WASH down the stem in Oxide of Chromium. Pro tip: You may find you enjoy the control that this small brush offers, so feel free to use it to complete your piece!

06. Repeat the process in step 5 for the leaves on the flower bud and stems, alternating the leaf WASH colors in Monstera and Oxide of Chromium.

07. By now, your blush floral petals should be dry, so it's time to paint the flower centers! Using your Round 1 brush, WASH the center of the first flower in Payne's Gray. Use your paper towel to BLOT out color from the very center of your wash, leaving a stained gradient of Payne's Gray. Use WET-ON-DRY (remember your thicker 50w/50p consistency!) to make small concentrated dabs of deep Payne's Gray adding small pops of saturated color to contrast with the blotted-out center wash.

08. Stand up, stretch, and go rinse out that wash water and your Round 1 brush until they run clear.

09. With your new clear wash water, let's add the WET-ON-DRY details to your petals that give these poppies such a pop! Using WET-ON-DRY and referencing the icon for inspiration, paint small concentrated line-shaped washes of Taupe in saturated lines on your petals.

10. Now use WET-ON-DRY to create one nice concentrated line of color in Taupe in your flower buds.

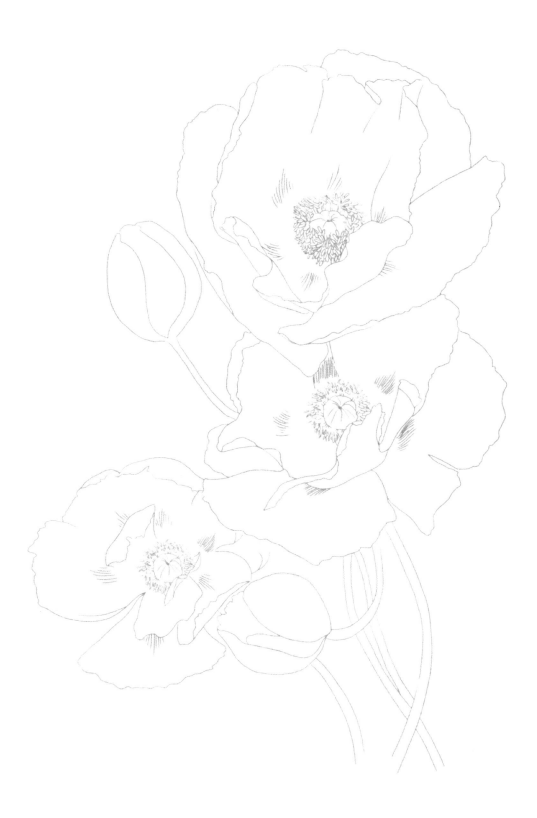

COLOR RECIPES:

BLUSH: 50% White + 30% Yellow Ochre + 20% Alizarin Crimson
MONSTERA: 60% Oxide of Chromium + 40% Payne's Gray
TAUPE: 10% White + 20% Yellow Ochre + 20% Alizarin Crimson + 50% Burnt Sienna

GARDEN BOUQUET

Brushes Needed:
ROUND 1 & 4

COLOR PALETTE:

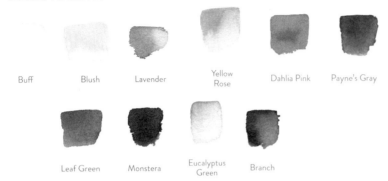

Buff · Blush · Lavender · Yellow Rose · Dahlia Pink · Payne's Gray

Leaf Green · Monstera · Eucalyptus Green · Branch

01. Using a waterproof pen, INK the design.

02. Decide how you'd like to treat your boundaries. The majority of this piece uses the "Loose Boundary" approach on page 21.

03. Notice how light the flowers are in the icon. To achieve this effect, you are going to be painting with just water for your washes. Pro tip: When working in pieces that have repeats of a similar flower, I like to paint all of them at the same time before moving onto a different type of flower. This keeps the palette mixing to a minimum.

04. Starting with your Round 4 brush, WASH a few petals of the lightest flowers (the three near the top) in water, and use WET-IN-WET to drop in Buff. You can RESERVE some of the petals, free from paint and water, with the white of the paper showing through. Pro tip: Wait on the smaller details of your piece, for example the stems and flower centers, until most of the larger elements are painted. Then you can switch to your Round 1 brush to paint in your details.

05. WASH the large central flower (the rose nearest the top) in just water.

06. Using WET-IN-WET, add concentrated dabs of Blush, Buff, and just a touch of Lavender. The colors will bleed and move into the wet areas of your flower. Continue to dab in color to build the saturation you desire.

07. While the flower is still wet, use the DRY BRUSH technique to sweep away any high concentration of color to create high-to-low contrast within the flower boundaries. You can also use your paper towel to BLOT away excess water or paint to create highlights.

08. For the other central flower (also a rose, with the center of the flower angled down) repeat the process in steps 5 through 7, using Buff, Blush, Yellow Rose, and Dahlia Pink.

09. WASH the remaining loose wildflowers using the same process in steps 5 through 7, using Lavender, Blush, and just the lightest touches of Payne's Gray near the center of the flowers.

10. While the flower boundaries dry, it's time to paint the larger leaf boundaries. Hopscotch around your piece, painting the larger leaves one at a time.

11. WASH your larger leaves in just water.

12. Use WET-IN-WET to dab in Leaf Green and Monstera at the base of each leaf, where it connects to the stem.

13. Switch to your Round 1 brush to complete the more detailed areas of this piece, as follows:

14. WASH the small leaves in Eucalyptus Green.

15. WASH the centers of your flowers in Branch or Yellow Rose.

16. Once the smaller leaves are dry, use your Round 1 brush again to add very small WASH lines in Branch along the stems and central veins of the botanicals. Use the more paint concentrated magic sauce of 50w/50p to achieve a saturated color with less water.

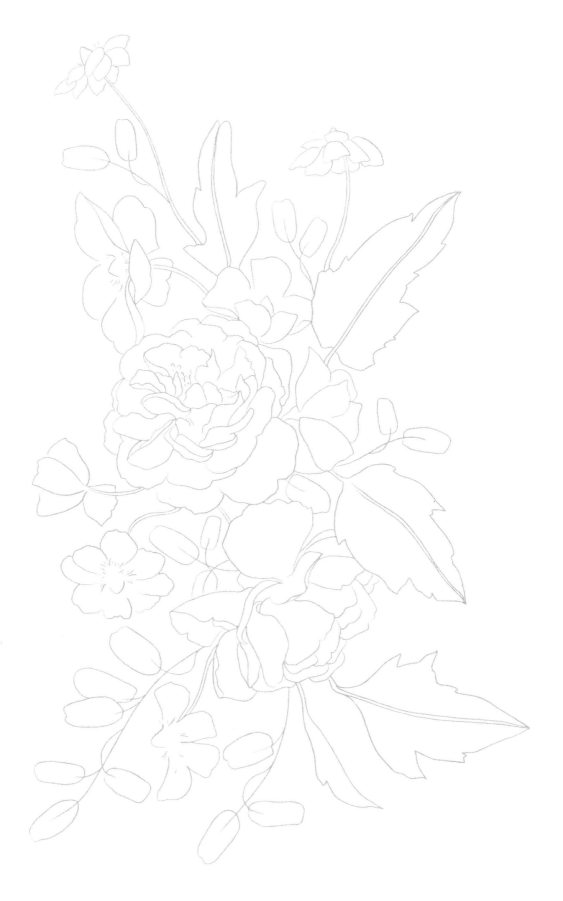

COLOR RECIPES:

BUFF: 90% White + 10% Yellow Ochre

BLUSH: 50% White + 30% Yellow Ochre + 20% Alizarin Crimson

LAVENDER: 10% White + 5% Yellow Ochre + 45% Payne's Gray + 40% Alizarin Crimson

YELLOW ROSE: 10% White + 80% Lemon Yellow + 10% Alizarin Crimson

DAHLIA PINK: 10% White + 19% Yellow Ochre + 30% Alizarin Crimson + 40% Burnt Sienna + 1% Ivory Black

LEAF GREEN: 20% Oxide of Chromium + 50% Burnt Sienna + 30% Payne's Gray

MONSTERA: 60% Oxide of Chromium + 40% Payne's Gray

EUCALYPTUS GREEN: 50% White + 10% Yellow Ochre + 20% Oxide of Chromium + 20% Cobalt Blue Hue

BRANCH: 40% Yellow Ochre + 50% Burnt Sienna + 10% Ivory Black

LADY WISTERIA

Brushes Needed:
ROUND 1 & 4

COLOR PALETTE:

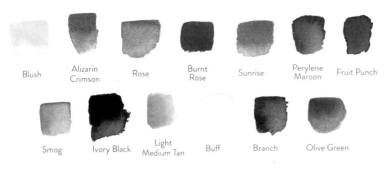

Blush Alizarin Crimson Rose Burnt Rose Sunrise Perylene Maroon Fruit Punch

Smog Ivory Black Light Medium Tan Buff Branch Olive Green

01. Using a waterproof pen, INK the design.

02. Decide how you'd like to treat your boundaries. The majority of this piece was painted using the "Undefined Boundary" approach on page 22, and the "Loose Boundary" approach for Lady Wisteria. Use your Round 4 for larger boundaries in this piece, and feel free to switch to your Round 1 for more detailed areas. For the smallest details in the piece, use just the lightest amount of pressure in order to make small marks.

03. Starting on the right side of your flower garland and using your Round 4 brush, use just water to WASH the first section of your flowers. RESERVE some petals as just the white of the paper, keeping them dry. Use WET-IN-WET to dab in Blush around the general area of your florals, alighting on a petal here, a petal there.

04. Move to the central area of your floral garland and use just water to WASH the middle section of your flowers. Leave some petals the white of the paper by not washing them and keeping them dry. Use WET-IN-WET to dab in a little Blush. Increase the saturation as you work to the left by dabbing in more Alizarin Crimson, Rose, Burnt Rose, and Sunrise to the general area of your florals, alighting again on a petal here, and sometimes an entire floral there. We are building deeper color as we move from right to left. Use the colors of your florals to WASH the flower in the plant lady's left hand.

05. For the final section of florals on the far right, use just water to WASH the flowers. Use WET-IN-WET to dab in a little Blush. Then increase the saturation even more as you work

down and to the left by adding more Alizarin Crimson, Rose, Burnt Rose, and Sunrise to the general area of your florals, alighting a petal here, an entire floral there. Add that last hit of saturated color with Perylene Maroon and Fruit Punch.

06. While the florals dry, WASH the lady's skirt in Smog.

07. WASH her hair in Branch, using WET-IN-WET to add in deep touches of Ivory Black.

08. WASH the skin tone of her arms. I used Light Medium Tan, but you may use any color from the skin tone recipes on page 27.

09. Now switch to your Round 1 brush for the details! Begin by adding very small hints of Buff to her shirt, using a thin WASH line at the edges of her shirt to suggest light linen.

10. Lightly WASH the vines and leaves in the garland, and the floral in her hand, alternating in Branch and Olive Green.

11. To really increase the saturation of some of the flowers and add a unique pop of beauty, return to your dry flower boundaries and use WET-ON-DRY to add small washes of intense color to select petals. Do this sparingly. You don't want to overwork the piece, and remembering to step back and let the paint do its beautiful watercolor work is one of the challenges of this artistic medium. Trust the process, and know that once everything is dry, you can always come back and add WET-ON-DRY pops of colors to highlight some flowers you'd like to emphasize later.

COLOR RECIPES:

BLUSH: 50% White + 30% Yellow Ochre + 20% Alizarin Crimson

ROSE: 10% White + 40% Yellow Ochre + 50% Alizarin Crimson

BURNT ROSE: 35% Burnt Sienna + 60% Alizarin Crimson + 5% Ivory Black

SUNRISE: 10% White + 80% Yellow Ochre + 10% Alizarin Crimson

PERYLENE MAROON SUBSTITUTE: 39% Burnt Sienna + 1% Ivory Black + 60% Alizarin Crimson

FRUIT PUNCH: 60% Perylene Violet + 40% Alizarin Crimson

SMOG: 40% White + 30% Yellow Ochre + 20% Alizarin Crimson + 10% Payne's Gray

LIGHT MEDIUM TAN: 70% White + 30% Burnt Sienna

BUFF: 90% White + 10% Yellow Ochre

BRANCH: 40% Yellow Ochre + 50% Burnt Sienna + 10% Ivory Black

OLIVE GREEN: 40% Oxide of Chromium + 60% Burnt Sienna

LADY BANANA PLANT

Brushes Needed:
ROUND 1 & 4

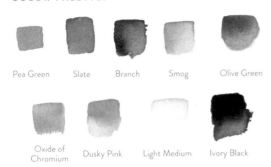

COLOR PALETTE:

Pea Green · Slate · Branch · Smog · Olive Green

Oxide of Chromium · Dusky Pink · Light Medium · Ivory Black

01. Using a waterproof pen, INK the design.

02. Decide how you'd like to treat your boundaries. I chose to use the "Defined Boundary" approach on page 21 to paint each banana leaf and element in this piece individually.

03. When painting in "Defined Boundary" style, one wet boundary cannot touch another; otherwise, the boundaries will bleed and blend for a totally different look. So, we will "hopscotch" around the piece, only painting areas that have dry neighbors.

04. Starting with your Round 4 brush, WASH your banana leaves in Pea Green. (Try to not paint over the leaf stem that runs down the center of each long banana leaf, leaving it white to increase contrast.) Some leaves show both the underside and topside of the leaf. When you come across an underside of a leaf, leave it the white of the paper for now. We will come back and WASH them in Slate.

05. While the banana leaves dry, switch to your Round 1 and WASH the seat in Branch. You may need less water and more paint in your consistency for these smaller boundaries.

06. While the seat dries, return to your (now dry!) banana leaves. WASH the undersides of the remaining leaves in Slate, using your Round 4.

07. Switch back to your Round 1 for the following detailed elements: WASH the plant pot and shoes in Smog.

08. Use the DRY BRUSH to sweep color away and create points of highlight within these wet boundaries.

09. While you wait for the pot and shoes to dry, revisit those dry banana leaves. Using the WET-ON-DRY technique and your Round 1 brush, paint thin WASHES of varying colors on top of your dried leaf washes, using a 50w/50p consistency. Alternate between Olive Green, Oxide of Chromium, and Slate to give some pop and pizazz to each leaf.

10. With your Round 1 brush and thicker paint consistency, WASH the stems of the banana leaves, alternating between Branch and Pea Green.

11. Once the overlapping leaves of the banana plant are dry, WASH the plant lady's sweatshirt in Dusky Pink. Use WET-IN-WET to increase the color saturation and the DRY BRUSH technique to sweep away any high concentration of color to create highlights.

12. Now it's time to paint the skin tone if you'd like. For this project, I used Light Medium, but you may choose any color from the skin tone recipes on page 27 and WASH using the color recipe you select.

13. Lastly, WASH her hair, sweatshirt cuffs, and front leg in Ivory Black. To create a bit of a highlight on her front leg, on her thigh, DRY BRUSH sweep color away to create a contrast within the wet wash. Once her front leg wash is dry, WASH the background leg in a mixture of Smog and Ivory Black. By waiting for the first wash boundary to dry, you're ensuring that the second lighter wash will not be overtaken by the darker color so that both legs will be defined.

COLOR RECIPES:

PEA GREEN: 70% Yellow Ochre + 30% Oxide of Chromium

SLATE: 30% White + 30% Oxide of Chromium + 40% Payne's Gray

BRANCH: 40% Yellow Ochre + 50% Burnt Sienna + 10% Ivory Black

OLIVE GREEN: 40% Oxide of Chromium + 60% Burnt Sienna

DUSKY PINK: 44% White + 1% Payne's Gray + 55% Alizarin Crimson

LIGHT MEDIUM: 80% White + 15% Yellow Ochre + 5% Lemon Yellow

SMOG: 40% White + 30% Yellow Ochre + 20% Alizarin Crimson + 10% Payne's Gray

LADY MONSTERA

Brushes Needed:
ROUND 1 & 4

COLOR PALETTE:

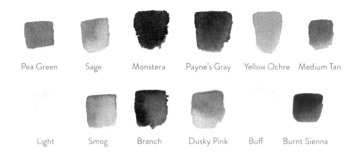

Pea Green · Sage · Monstera · Payne's Gray · Yellow Ochre · Medium Tan

Light · Smog · Branch · Dusky Pink · Buff · Burnt Sienna

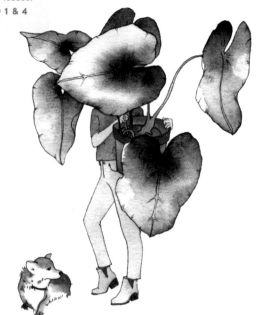

01. Using a waterproof pen, INK the design.

02. Decide how you'd like to treat your boundaries. As you can see in the icon, I chose to use the "Defined Boundary" approach. Use your Round 4 for larger boundaries in this piece, and feel free to switch to your Round 1 for more detailed areas.

03. Using just water and your Round 4 brush, WASH your first leaf. You get to decide which leaf you begin painting on this piece, but I would suggest that if you're left-handed, start on the right, and if you're right-handed, start on the left. You will reduce the chances of running your hand through your drying work. Then, beginning at the top and center of your leaf, use WET-IN-WET to build color by dabbing in Pea Green first, followed by Sage, then Monstera, and finally Payne's Gray. Use your paintbrush to sweep the color down the leaf if it needs a bit of encouragement to move.

04. Use the DRY BRUSH technique to sweep away any high concentration of color. You can also use your paper towel to gently BLOT away excess water or paint to create highlights.

05. Repeat steps 3 and 4 for the rest of the leaves. If you want to follow the "Defined Boundary" approach, when you get to the four leaves that overlap on the left side of the piece, make sure to wait until the wet leaf you've been working on is completely dry before beginning your next leaf, as you do not want these boundaries bleeding into one another. Waiting will give you the kind of definition you want between leaves.

06. While you are painting leaves and waiting for them to dry, WASH the sweet pet dog in Yellow Ochre and Medium Tan, RESERVING the white paper, so it shows through in some spots for natural areas of white fur.

07. WASH her skin tone. For this project, I used Light, but you may use any color from the skin tone recipes on page 27.

08. WASH her trousers in Smog.

09. WASH the soil in Branch.

10. WASH her shirt in Dusky Pink.

11. WASH her boots in Buff. Once they are dry, return with your Round 1 brush and use WET-ON-DRY to paint her boot details in Branch.

12. While you have your Round 1 brush handy and wet, paint the thin stems of the monstera plant with a WASH, alternating the same colors you used for the leaves.

13. WASH the plant pot in Burnt Sienna, treating the outside rim of the pot, the inside rim of the pot, and the actual pot as individual boundaries. This means you will need to wait for boundaries to dry and hopscotch around to only paint areas that have dry boundaries. That will give you hard lines, helping to define the form of the pot.

COLOR RECIPES:

PEA GREEN: 70% Yellow Ochre + 30% Oxide of Chromium

SAGE: 50% White + 20% Yellow Ochre + 30% Oxide of Chromium

MONSTERA: 60% Oxide of Chromium + 40% Payne's Gray

MEDIUM TAN: 30% White + 15% Yellow Ochre + 5% Lemon Yellow + 40% Burnt Sienna + 10% Ivory Black

LIGHT: 80% White + 20% Burnt Sienna

SMOG: 40% White + 30% Yellow Ochre + 20% Alizarin Crimson + 10% Payne's Gray

BRANCH: 40% Yellow Ochre + 50% Burnt Sienna + 10% Ivory Black

DUSKY PINK: 44% White + 1% Payne's Gray + 55% Alizarin Crimson

BUFF: 90% White + 10% Yellow Ochre

BERRIES & CYPRESS

Brushes Needed:
ROUND 1 & 4

01. Using a waterproof pen, INK the design.

02. Decide the approach you'd like to take for your boundaries. As you can see in the icon, I chose to use the "Defined Boundary" approach on page 21 for every leaf and berry, and a "Loose Boundary" approach for the central flower.

03. When painting in a "Defined Boundary" style, one wet boundary cannot touch another; otherwise, the boundaries will bleed and blend for a totally different look. So, we will "hopscotch" around the piece, only painting flowers, leaves, and berries that have dry neighbors.

04. Beginning at the bottom of the piece, WASH your smaller flowers in just water for a very light wash using your Round 1 brush.

05. Use WET-IN-WET to add dabs of Blush and Buff. The colors will bleed and move into the wet areas of your flowers. Continue to dab in color to build the saturation of paint you desire.

06. While your flowers are wet, use the DRY BRUSH technique to sweep away any high concentration of color to create a high-to-low contrast within the flower boundaries. You can also use your paper towel to gently BLOT away excess water or paint to create highlights.

07. While these light flower boundaries dry, it's time to WASH the larger leaf boundaries. Hopscotch around your piece, painting all of your leaves in varying shades of Pea Green, Sage, Olive Green, and Payne's Gray using your Round 4 brush. Feel free to reference the icon for ideas for where to put each color. Pro tip: Paint the smaller details of your piece after you've filled in most of the larger elements. Then you can switch to your Round 1 brush to paint in your stems and smaller leaf boundaries, as well as the cypress branch (the botanical on the very left-hand side of the design).

08. For the large blue leaves, follow the process in steps in 4 through 6 using Payne's Gray to achieve that same high-low contrast.

09. While your larger leaf boundaries are drying, it's time to paint the center flower. In the icon, I gave the entire flower its own boundary, meaning that the whole flower is wet at the same time. (You could also treat each petal as its own boundary. It may take a bit longer, but by detailing each petal, only wetting one at a time, your finished piece will pop and really show off your central flower.)

10. WASH the entire flower in Blush.

11. Use WET-IN-WET to drop in accent colors of Buff, Dahlia Pink, Sunrise, and Yellow Ochre to create points of high saturation.

12. While the flower is still wet, use the DRY BRUSH technique to sweep away any high concentration of color to create high-to-low contrast within the boundary. You can also use your paper towel to gently BLOT away excess water or paint to create highlights.

13. Grab your Round 1 brush to paint in the remaining details. For these smaller boundaries, you may want to add a bit more paint to your palette for a slightly thicker consistency—50w/50p should be a good ratio.

14. WASH your berries in alternating colors of Yellow Ochre and Pea Green, using WET-IN-WET to drop in higher concentrations of those same colors. Use the DRY BRUSH technique to sweep away any high concentration of color to create high-to-low contrast within the boundary. You can also use your paper towel to gently BLOT away excess water or paint to create highlights.

15. Begin by painting the smaller stems and leaves furthest from the central flower and berries to avoid unwanted bleeding between wet boundaries.

16. WASH your small stem boundaries in Branch.

17. WASH your small leaf boundaries in alternating colors of Pea Green, Sage, and Olive Green.

18. WASH your cypress branch last, alternating your colors within the branch using Olive Green, Payne's Gray, Buff, Yellow Ochre, and Branch.

COLOR PALETTE:

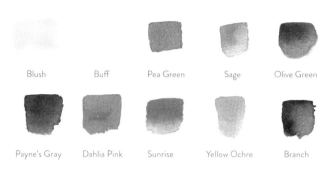

Blush Buff Pea Green Sage Olive Green

Payne's Gray Dahlia Pink Sunrise Yellow Ochre Branch

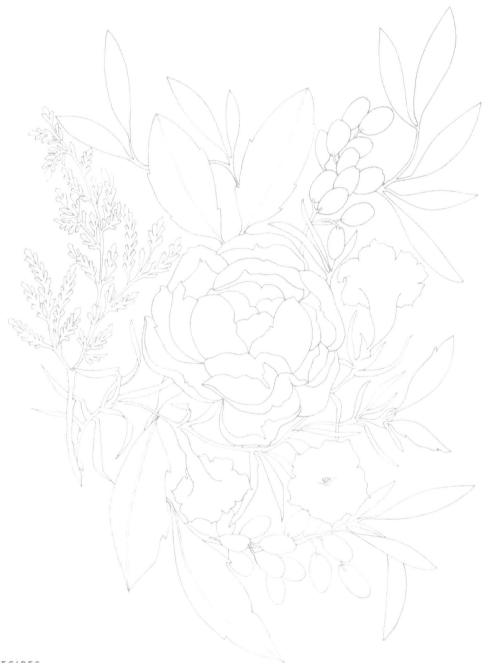

COLOR RECIPES:

BLUSH: 50% White + 30% Yellow Ochre + 20% Alizarin Crimson

BUFF: 90% White + 10% Yellow Ochre

PEA GREEN: 70% Yellow Ochre + 30% Oxide of Chromium

SAGE: 50% White + 20% Yellow Ochre + 30% Oxide of Chromium

OLIVE GREEN: 40% Oxide of Chromium + 60% Burnt Sienna

DAHLIA PINK: 10% White + 19% Yellow Ochre + 30% Alizarin Crimson + 40% Burnt Sienna + 1% Ivory Black

SUNRISE: 10% White + 80% Yellow Ochre + 10% Alizarin Crimson

BRANCH: 40% Yellow Ochre + 50% Burnt Sienna + 10% Ivory Black

LADY LILY

Brushes Needed:
ROUND 1 & 4

COLOR PALETTE:

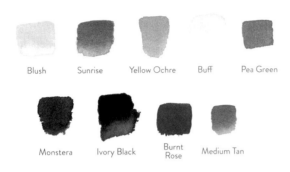

Blush Sunrise Yellow Ochre Buff Pea Green

Monstera Ivory Black Burnt Rose Medium Tan

01. Using a waterproof pen, INK the design.

02. Decide the approach you'd like to take for your boundaries. I chose to use the "Defined Boundary" approach on page 21. Use your Round 4 for larger boundaries in this piece, and feel free to switch to your Round 1 for more detailed areas.

03. Starting at the top and using your Round 4 brush, WASH your first lily flower in Blush. At the top and center of each petal (where the petal meets the flower center), use WET-IN-WET to build color by dabbing in Sunrise first, followed by Yellow Ochre. Use your paintbrush to sweep the color down the petal if it needs a bit of encouragement to move.

04. Use the DRY BRUSH technique to sweep away any high concentration of color to create high-to-low contrast within the boundary. You can also use your paper towel to gently BLOT away excess water or paint to create highlights. Leave the white of the paper showing by RESERVING parts of your petals, like the icon, for added contrast.

05. Paint the rest of the flowers following steps 3 and 4. Leave the very end stamen points of the flowers without color for now—we will come back to these at the very end.

06. While your flowers dry, WASH the lady's shirt in Buff.

07. Next, WASH her trousers in Pea Green and use WET-IN-WET to dab in more Pea Green as you paint to ensure they dry in a nice rich saturation of color.

08. To get this beautiful high-to-low contrast for the lily leaves, we'll start with a clear wash. Using just water, WASH the larger leaf elements at the top and use WET-IN-WET to

dab in monstera. Use just the point of your Round 4 brush (or switch to your Round 1) to draw the wet paint out into the thinner stems. Repeat this process for all of your leaves and stems. Pro tip: This is a good time to check your wash water! You want clear water before you paint the cat.

09. Using just water, WASH the cat. Use WET-IN-WET to dab in Ivory Black, adding concentrated color to the fur where you'd like it to be darkest. RESERVE the white of the paper to make unique markings. Feel free to model your cat after the one in the icon, or paint her based on your own favorite pet friend! Hold off on painting the face for now. We'll come back to those details.

10. WASH the lady's shoes in Burnt Rose, using your Round 1 brush for the smaller details.

11. WASH her hair in Ivory Black, using your Round 1 brush for the details around the flower.

12. WASH her skin tone. I used Medium Tan, but you may use any color from the skin tone recipes on page 27.

13. Using WET-ON-DRY and Round 1 brush, WASH the end tips of the flower stamens in Yellow Ochre. Notice I left the center stamens of the lilies as the white of the paper. Feel free to do the same or select a color to paint them.

14. Using WET-ON-DRY, feel free to add a few concentrated strokes of Buff to Lady Lily's shirt, near the line marks you drew in, to create shadow.

15. Go back to the cat and use WET-ON-DRY to add the details of eyes and any extra darker fur elements in Ivory Black.

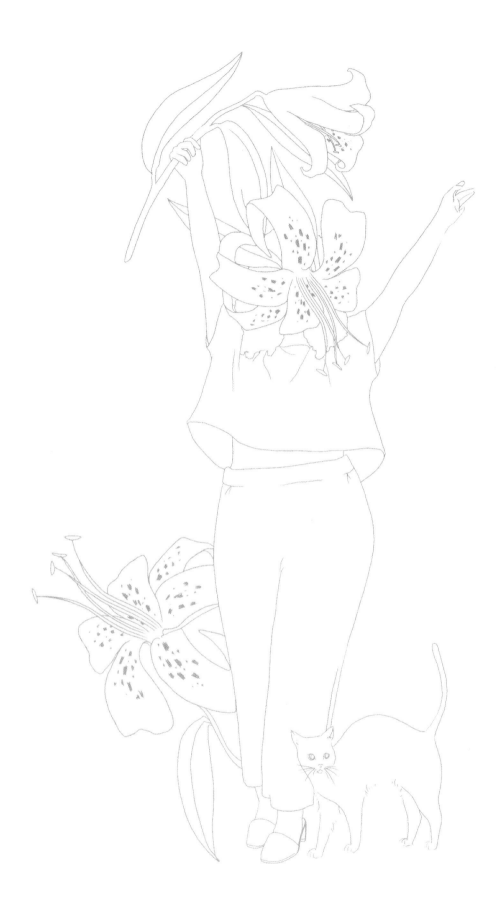

COLOR RECIPES:

BLUSH: 50% White + 30% Yellow Ochre + 20% Alizarin Crimson

SUNRISE: 10% White + 80% Yellow Ochre + 10% Alizarin Crimson

BUFF: 90% White + 10% Yellow Ochre

PEA GREEN: 70% Yellow Ochre + 30% Oxide of Chromium

MONSTERA: 60% Oxide of Chromium + 40% Payne's Gray

BURNT ROSE: 35% Burnt Sienna + 60% Alizarin Crimson + 5% Ivory Black

MEDIUM TAN: 30% White + 15% Yellow Ochre + 5% Lemon Yellow + 40% Burnt Sienna + 10% Ivory Black

01. Using a waterproof pen, INK the design.

02. Decide how you'd like to treat your boundaries. I chose to use the "Defined Boundary" approach on page 21 to give each flower and leaf its own boundary. Pro tip: To get this beautiful high-to-low contrast in your botanical elements, it's best to start with a clear wash. I like to work from lightest to darkest in color saturation, to save trips to refill my water.

03. Using just water and your Round 4 brush, WASH your first magnolia flower using WET-IN-WET to dab in Buff. Leave the centers for now—we'll come back to these later. Repeat this process for the other two magnolias.

04. Notice that some of the cosmos are turned up at the edges. Try to leave these areas—as well as the center of the cosmos—RESERVED and dry with the white of the paper showing through. We'll come back to these later.

05. WASH your top right cosmos flower in Rose, RESERV-ING some white in the petals, and not worrying too much about painting perfectly within the lines. Use WET-IN-WET to dab in Dahlia Pink and Sunrise. If you have Perylene Maroon, dab it into the wet washes of these flower petals as well for a dramatic saturated effect. Repeat this process for the other two cosmos.

06. Starting at the top of your piece, WASH the cosmos greenery in Olive Green, using your Round 1 brush to paint the thinner stems. Use WET-IN-WET to dab in more Olive Green to build deeper color in some leaves as well as the cosmos bud in the upper left-hand corner.

07. Using just water, WASH your first magnolia leaf. Using WET-IN-WET, and beginning at the top and center of your leaf (where the stem would meet the leaf) dab in Eucalyptus

Green, followed by Monstera, and finally, Payne's Gray. Use your paintbrush to sweep the color down the leaf if it needs a bit of encouragement to move.

08. Use the DRY BRUSH technique to sweep away any high concentration of color. You can also use your paper towel to gently BLOT away excess water or paint to create highlights.

09. Repeat steps 7 and 8 for the rest of the leaves. When you get to any overlapping leaves, make sure to wait until the wet leaf you've been working on is completely dry before beginning your next leaf, so the wet boundaries do not bleed into one another. Waiting will give you nice hard drying lines and the kind of definition you want between leaves.

10. While you're painting these leaves and waiting for bound-aries to dry, set aside another jar of clear water and your small Round 1 brush to work on the following details.

11. Using your Round 1 brush, WASH the cosmos petals that were folded up or over (the areas you left white in step 4 in a light Sunrise). This will differentiate their boundaries and add interest to each flower.

12. Now it's time to go back to the centers of your florals. WASH the center of your magnolia flowers in Ivory Black. Using very small marks with just the point of your brush, add the centers of your cosmos flowers by making small dots of color in Yellow Ochre, Payne's Gray, and Branch. If you end up with too much water in the dots, use your paper towel to BLOT excess water.

13. Finish up any leaves left unpainted from step 9.

COLOR PALETTE:

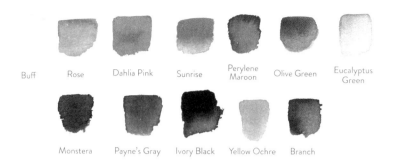

Buff Rose Dahlia Pink Sunrise Perylene Maroon Olive Green Eucalyptus Green

Monstera Payne's Gray Ivory Black Yellow Ochre Branch

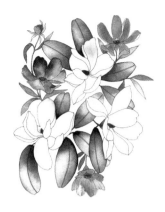

COLOR RECIPES:

BUFF: 90% White + 10% Yellow Ochre

ROSE: 10% White + 40% Yellow Ochre + 50% Alizarin Crimson

DAHLIA PINK: 10% White + 19% Yellow Ochre + 30% Alizarin Crimson + 40% Burnt Sienna + 1% Ivory Black

SUNRISE: 10% White + 80% Yellow Ochre + 10% Alizarin Crimson

PERYLENE MAROON SUBSTITUTE: 39% Burnt Sienna + 1% Ivory Black + 60% Alizarin Crimson

OLIVE GREEN: 40% Oxide of Chromium + 60% Burnt Sienna

EUCALYPTUS GREEN: 50% White + 10% Yellow Ochre + 20% Oxide of Chromium + 20% Cobalt Blue Hue

MONSTERA: 60% Oxide of Chromium + 40% Payne's Gray

BRANCH: 40% Yellow Ochre + 50% Burnt Sienna + 10% Ivory Black

PLANT LADY BESTIES

Brushes Needed:
ROUND 1 & 4

COLOR PALETTE:

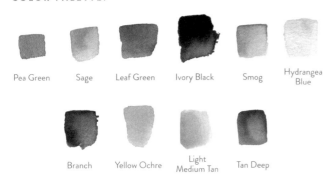

Pea Green Sage Leaf Green Ivory Black Smog Hydrangea Blue

Branch Yellow Ochre Light Medium Tan Tan Deep

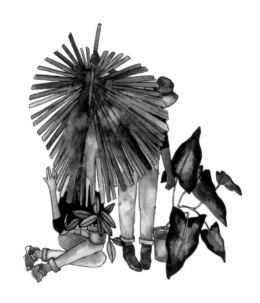

01. Using a waterproof pen, INK the design.

02. Decide how you'd like to treat your boundaries. As you can see in the icon, I chose to use the "Defined Boundary" approach on page 21. Use your Round 4 for larger boundaries in this piece, and feel free to switch to your Round 1 for more detailed areas.

03. Starting with your Round 4 brush, WASH the main, central flower in Pea Green.

04. Using WET-IN-WET, add dabs of Sage and Leaf Green.

05. WASH the leaves of the small potted plant on the left, keeping each leaf a small boundary of Sage and Leaf Green.

06. Move to the other potted plant, on the right, and paint each leaf as its own individual boundary. Avoid painting the leaf stems, RESERVING the white of your paper in these areas. Follow steps 7 and 8 for each leaf on this plant.

07. WASH each leaf in Pea Green.

08. Use WET-IN-WET to add Leaf Green along the edges of the wet leaf boundary. While your leaf is still wet, use WET-IN-WET to add Ivory Black all along the edges of the wet leaf boundary. By this point, your leaf is on its way to drying, so the darker tones of the Ivory Black will not bleed as quickly, leaving the center a lighter green and the edges a much deeper color. Repeat this process for the remainder of the leaves in this potted plant.

09. WASH both of the plant ladies' shirts in Ivory Black.

10. WASH both of the plant ladies' trousers in Smog. Using WET-IN-WET, drop in Hydrangea Blue, and then use the DRY BRUSH technique to sweep away paint and create highlights within the wet jean boundary. You can also BLOT out excess paint and water with your paper towel to give the jeans texture and a nice faded wash look.

11. WASH the standing plant lady's boots and hat in Branch. There is a defined band around the hat—it's OK to paint over that for now. We will come back to it later.

12. WASH the sitting plant lady's sandals in Branch with a touch of Yellow Ochre.

13. WASH the terracotta plant pots in Light Medium Tan. Use the DRY BRUSH technique to sweep away paint and create highlights within the pot base to mimic a reflection of light. You can also use your paper towel to BLOT excess water or paint to create highlights.

14. Once all the boundaries touching the plant ladies' skin are dry, you can paint their skin tone if you'd like! Following the icon, the standing plant lady's skin tone is Tan Deep and the sitting plant lady's Light Medium Tan, but you may use any color from the skin tone recipes on page 27.

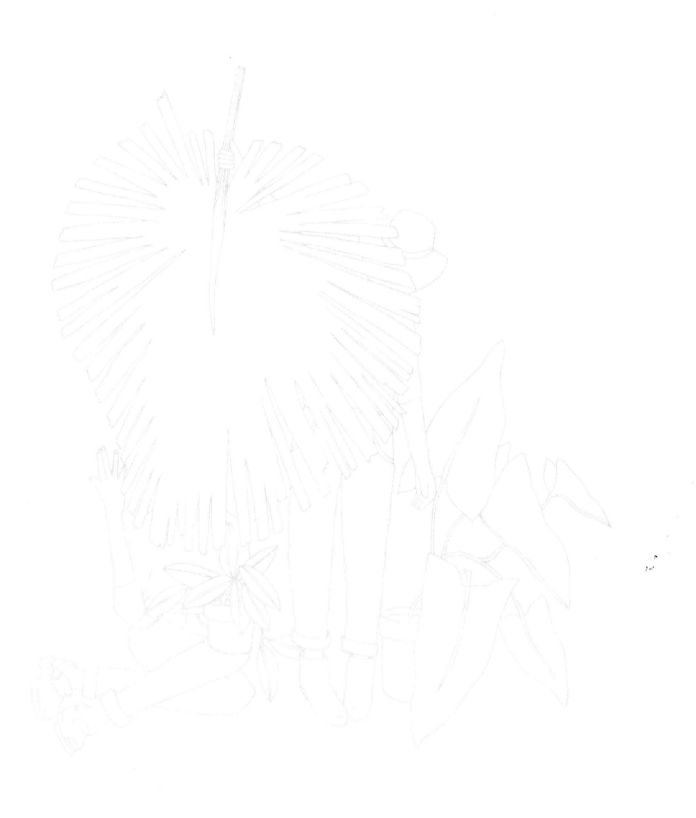

COLOR RECIPES:

PEA GREEN: 70% Yellow Ochre + 30% Oxide of Chromium

SAGE: 50% White + 20% Yellow Ochre + 30% Oxide of Chromium

LEAF GREEN: 20% Oxide of Chromium + 50% Burnt Sienna + 30% Payne's Gray

SMOG: 40% White + 30% Yellow Ochre + 20% Alizarin Crimson + 10% Payne's Gray

HYDRANGEA BLUE: 50% White + 10% Lemon Yellow + 40% Cobalt Blue Hue

BRANCH: 40% Yellow Ochre + 50% Burnt Sienna + 10% Ivory Black

LIGHT MEDIUM TAN: 70% White + 30% Burnt Sienna

TAN DEEP: 20% White + 10% Yellow Ochre + 5% Lemon Yellow + 45% Burnt Sienna + 15% Ivory Black + 5% Alizarin Crimson

ACKNOWLEDGMENTS

I would like to thank all of the Blue Star Press team who made this book happen. Lindsay, Clare, Megan, and Peter: you are all rock stars! Your research, patience, and humor made this book such a joy to create.

I would also like to thank the following "Recipe Testers." These friends took the time out of their busy lives to paint these lessons, try out the steps, and fine tune each project for the enjoyment of all. Thank you Courtney Clark, Su Yin Khor, Elisa McLaughlin, Aurelie Trier, Elizabeth Dack, and Xue Lee. I am so appreciative of your input, your insight, your help, and your time!

And finally, congratulations to YOU! Thank you for spending your creative moments in the pages of this *Watercolor Workbook*. I hope this is just the beginning of your painting journey. I cannot wait to see what you create!